THE ART OF
STAINED AND DECORATIVE
GLASS

ELIZABETH WYLIE

SHELDON CHEEK

TODTRI

This book was designed and produced by
Todtri Productions Limited
P.O. Box 572, New York, NY 10116-0572
FAX: (212) 279-1241

Printed and bound in Singapore

ISBN 0-7651-9226-8

Authors: Elizabeth Wylie & Sheldon Cheek

Publisher: Robert M. Tod
Editorial Director: Elizabeth Loonan
Book Designer: Mark Weinberg
Senior Editor: Cynthia Sternau
Project Editor: Ann Kirby
Photo Editor: Edward Douglas
Picture Researchers: Laura Wyss, Meiers Tambeau
Production Coordinator: Jay Weiser
Desktop Associate: Paul Kachur
Typesetting: Command-O Design

PICTURE CREDITS

Alinari—Art Resource, New York 47

Art Institute of Chicago 92–93, 116

Art Resource, New York 104–105

Chrysler Museum, Norfolk 97, 107

Cooper-Hewitt, National Design Museum, New York 103

Corning Museum of Glass 127

Eric Thorburn 88–89

Erich Lessing—Art Resource, New York 10, 15, 16, 18 (left & right),
19 (left & right), 24–25, 28, 39, 42, 43, 45, 46, 48, 50, 51 (left & right),
52, 53, 54, 58, 66, 67, 69, 71, 72–73

Giraudon—Art Resource, New York 11 (top), 21, 30, 36–37, 44,
56–57, 65, 70, 75, 91, 123, 125

Glasgow Picture Library 88–89

Hunterian Art Gallery, Glasgow 88 (left)

Inventaire Général 76, 90

John D. Wolf 6, 96

Joseph Albers Foundation 122

Metropolitan Museum of Art, New York 64, 108, 110, 111, 112, 113, 115

Minneapolis Institute of Arts 124

Musée d'Orsay 94

Musée Georges Pompidou 4

Museum of Fine Arts, Boston 100, 114

National Gallery of Art, Washington, DC 7

National Museum of American Art, Washington, DC
—Art Resource, New York 12, 95, 98, 99

National Portrait Gallery, Smithsonian Institute
—Art Resource, New York 14 (bottom)

Picture Perfect
Arnold J. Kaplan 126

Scala—Art Resource, New York 13, 26, 31, 33, 35, 38, 55

Scibilia—Art Resource, New York 5, 22, 23, 27, 29, 34, 40–41

Stroh Brewery Company 14 (top)

Superstock 8–9, 11 (bottom), 32, 78, 79, 106

Thomas A. Heinz 117, 118, 118–119

Toledo Museum of Art 59, 60–61

Tzovaras—Art Resource, New York 120–121

Victoria & Albert Museum—Art Resource, New York 62, 63,
80, 81, 82, 83, 84, 85, 86, 87

Virginia Museum of Fine Arts 101, 102

CONTENTS

INTRODUCTION
4

CHAPTER ONE
GOTHIC STAINED GLASS
17

CHAPTER TWO
NEW HORIZONS OF THE RENAISSANCE
49

CHAPTER THREE
REVIVAL IN THE AGE OF PROGRESS
77

CHAPTER FOUR
STAINED GLASS AND THE MODERN AGE
109

INDEX
128

INTRODUCTION

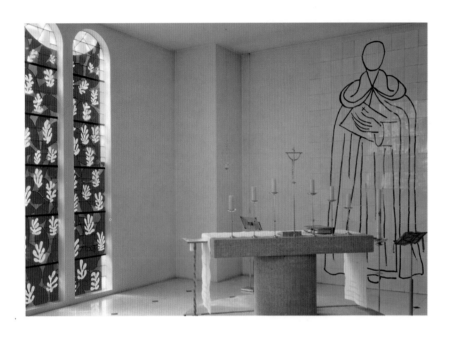

Dominican Chapel at Vence

Henri Matisse. Photo RMN—H. del Olmo. Musée Georges Pompidou, Paris. Henri Matisse designed every aspect of this chapel, from the vestments and chalice to the altar, tile mural, and stained glass. The vibrant *Tree of Life* window, executed by Paul Bony, is related to Matisse's experiments with paper cutouts.

THE CONTINUITY OF GLASS

Glass is a medium as old as history. The same early cultures that discovered bronze also found a way to combine several substances into something new: glass. The properties of fused silica, the major ingredient of glass, are those of neither a conventional liquid nor a solid. Technically known as a "supercooled liquid," glass does not crystallize upon leaving the furnace. Instead, it remains absolutely uniform in consistency. This property gives glass of all kinds—opaque or transparent, clear or colored—a uniquely refractive, sparkling quality when penetrated by light.

The Sumerians used vitreous glaze to color cone-shaped tiles for their great temples, and by the second millennium B.C., vessels in the Egyptian New Kingdom were made entirely of coiled and colored glass. The ancient Greeks and Romans developed equally ingenious and colorful forms of wrought glass, such as *millefiori*

vases and intricately carved cage cups. Around the first century B.C., the technique of glass-blowing was invented, probably in Syria. The blowpipe ushered in a new era for glassworking.

The Romans used panes of clear, blown glass in the windows of extremely lavish homes, but what is thought of today as stained glass only began to emerge in the Christian era. Today, the refractive quality of stained glass is still appreciated for its unique properties of substance and metaphor. Many works of stained glass— such as the stylized organic forms of Henri Matisse's windows for the Chapel of the Rosary in Vence, France—are religious in nature. Matisse's windows and other works in stained glass are some of the greatest contributions to religious art of the twentieth century and affirm the enduring, ever-adapting quality of the medium of stained glass.

STAINED GLASS AS METAPHOR

The art of stained glass has always occupied a special place in the popular imagination. The translucent, radiant quality of the medium produces an aesthetic experience entirely different from that of any other art form.

Frescoes, paintings, and manuscript illuminations are viewed by light reflected onto their surfaces. With stained glass, however, white

Rheims Cathedral, west façade

Rose window with glazed triforium and tympanum below; mid-thirteenth century; d. 40 ft. (12.2 m). Rheims, France. The power of stained glass to contribute to the effect of a cathedral interior was realized as increasing amounts of wall surface were turned over to stained glass. Here the double rose window and the horizontal band (triforium) between them occupy what usually held figurative or decorative sculpture.

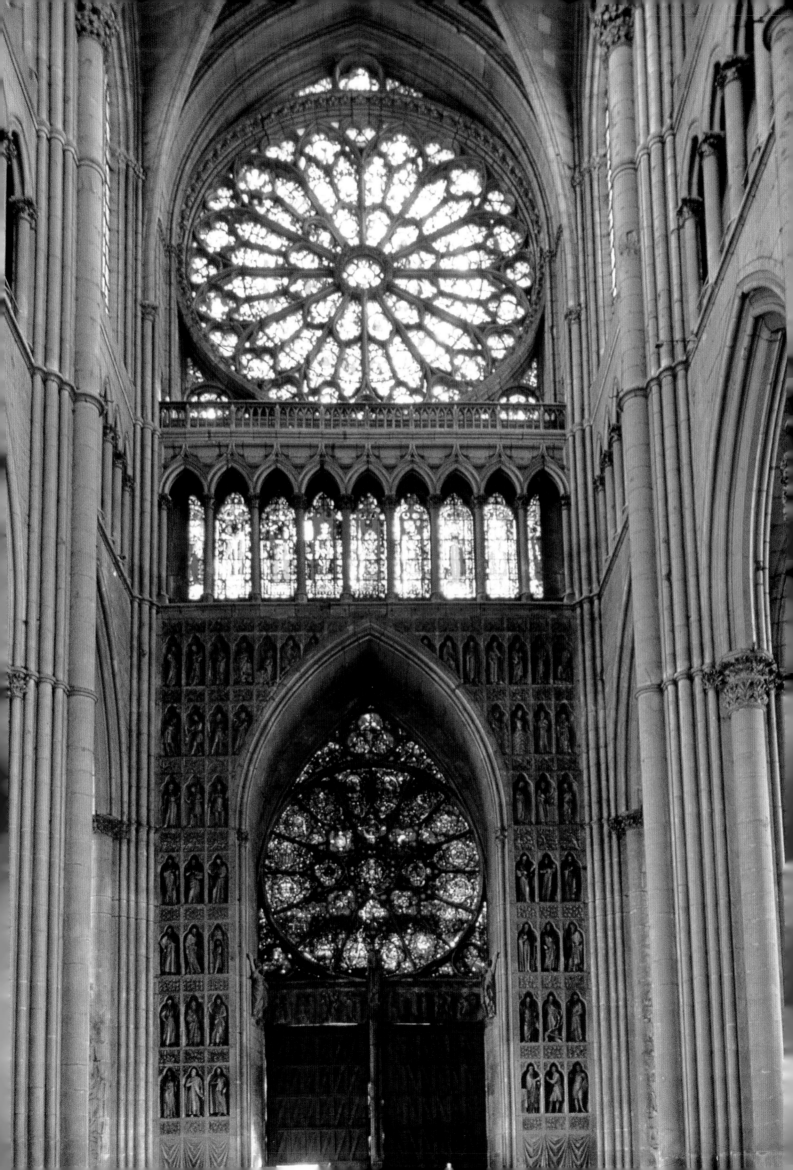

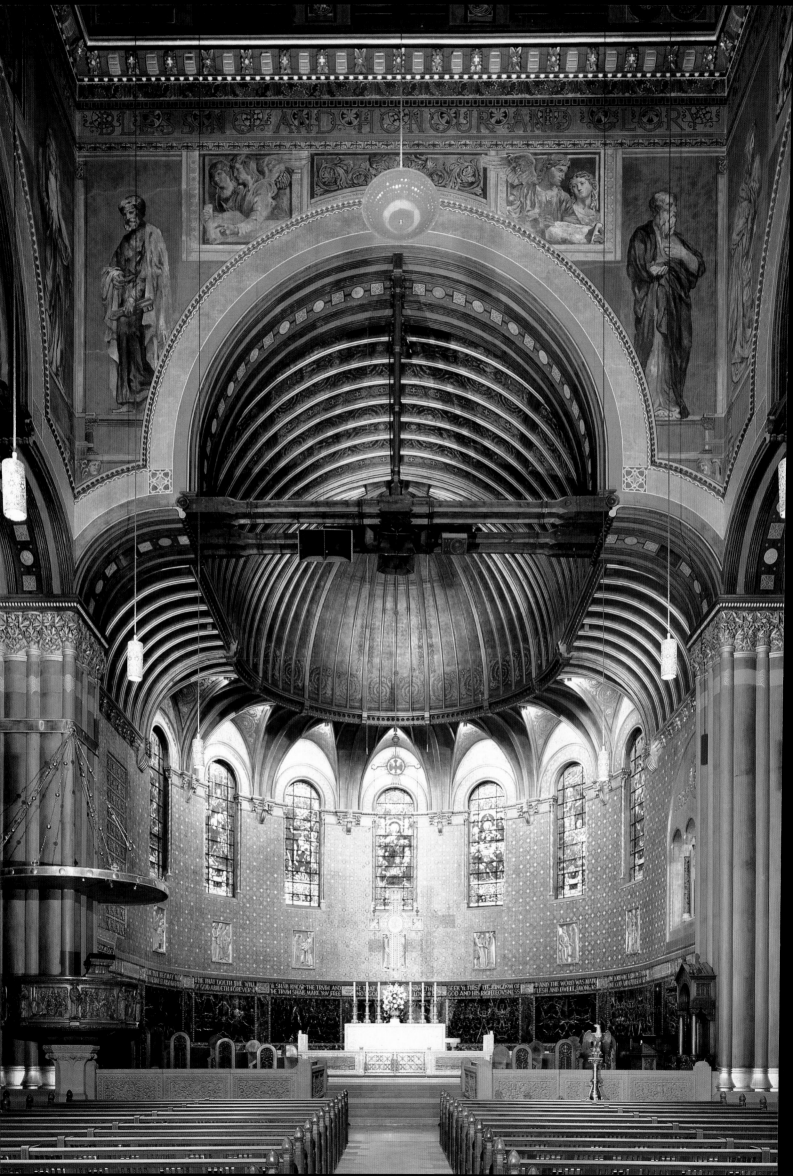

light passes through pigmented glass to release the brilliant hues making up the light spectrum. The observer is awed by the splendor of glowing color produced purely by the radiance of light.

The history of stained glass is rooted in architecture. For its effect, most stained glass depends on a spatial and structural context. The experience of a great church interior filled with stained glass and glittering with all manner of jewel-like materials is felt to be the embodiment of heaven. In the Middle Ages, churches were the meeting places of heaven and earth, sanctified by the Virgin Mary. Jan van Eyck's painting *The Annunciation* depicts Mary's miraculous presence in the sanctuary surrounded by visual references to her role as mother of Christ and Queen of Heaven.

Stained glass continues to elicit emotional and aesthetic reactions, even in our largely secular world. In his novel *Remembrance of Things Past*, Marcel Proust (1871–1922) describes a stream of personal memories and associations brought forth as his narrator, Swann, contemplates a stained glass window:

> [Its] colors died away and were rekindled by turns, a rare and transient fire the next instant, it had taken on all the iridescence of a peacock's tail, then shook and wavered in a flaming and fantastic shower. . . . And even on our first Sundays, when we came down before Easter, it would console me for the blackness and bareness of the earth outside by making burst into blossom, as in some springtime in old history among the heirs of Saint Louis, this dazzling and gilded carpet of forget-me-nots in glass.

Trinity Church, interior view of nave

H.H. RICHARDSON, architect, decoration by
John La Farge, et al. Boston, Massachusetts.
Stained glass is one of the many art forms used by John La Farge to decorate Boston's Trinity Church. Designed by H.H. Richardson, the building is decidedly Romanesque in effect, but La Farge's decorations draw on a range of sources, including Byzantine, Romanesque, and Renaissance art.

Stained glass is inextricably associated with the power and mystery of church. In popular culture, the mere suggestion of stained glass is a code for a church setting and the authority behind it. The Disney artists who animated the film of Victor Hugo's *Hunchback of Notre Dame*

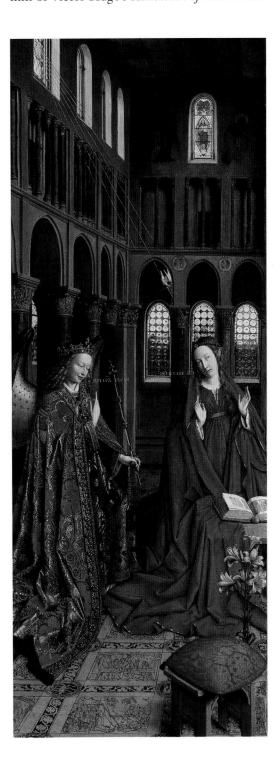

FOLLOWING PAGE:

The Triumphant Return of David

Detail; Chateau at Ecoun; n.d.
Ecoun, France.
While an intricate, multi-colored window fills a room with dazzling color, the overall effect can sometimes overwhelm and detract from the narrative of the window. A monocrhome scale, as here, becomes illuminated by light while allowing viewers to focus their attention on the subject and story of the scene.

The Annunciation

JAN VAN EYCK, c. 1434–36;
oil on canvas, transferred
from panel; 35⅜ x 13⅞ in.
(9.02 x 34.1 cm). National
Gallery of Art, Washington, DC.
As this painting illustrates, Gothic church interiors strived to evoke the kingdom of heaven through symbol-laden stained glass, intaglio floor tiles, woven garments, jeweled metal work, and other materials. These combined to create an otherworldly place for prayer and reflection.

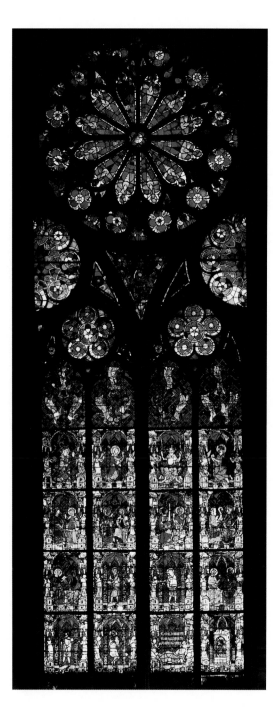

**Strasbourg
Cathedral,
south transept**

Rose and lancet windows.

Strasbourg, France.

Monumental in scale,
these windows fairly
overwhelm the viewer.
The design moves
downward from the
abstract celestial bril-
liance of the rose
window through the
triads of angels in
the intermediate
zone to the figur-
ative representations
of the celestial court
and Christian ideals.

Broadway shows to music videos and television programs—Madonna's "Like a Prayer" video and *Saturday Night Live's* "Church Lady" set both feature stained glass—and every soap opera has a hospital chapel identified as such with stained glass.

The strength of stained glass's significance in the popular imagination is not likely to diminish. The compelling experience of a Gothic cathedral with stained glass, such as the one at Chartres, insures their continued attraction as tourist destinations and their enduring nature as a place for spiritual connectedness.

STAINED GLASS TECHNIQUES

The traditional techniques of stained glass making were clearly established by the eleventh century. Details of the medieval process, which is much the same one used today by some artists, are known from a technical treatise on the arts written around 1100 by a German monk, Theophilus.

The process starts with silica, the major component of sand. Fine river-washed sand is preferred, and some have attributed the striking colors of the windows at Chartres to the purity of the sand found in that region. With the sand is mixed a potash of burned beechwood as a fluxing agent to lower the melting point of the silica. Lime follows, to stabilize the mixture.

Medieval glass was made in domed kilns with a clay pot serving as the crucible. Powdered metallic oxides, the same ones used to make paints, were added to the molten glass to produce a relatively narrow range of colors: cobalt oxide for blue, manganese for purple, and copper or iron oxide for green. A deep ruby red was made by a process known as "flashing," coating white glass with a thin layer of glass colored with cupric oxide.

In the Middle Ages, it was particularly hard to make clear, or white, glass. Technical limitations produced a white glass often tinged with yellow or blue.

The molten glass, known as "pot metal," was made in relatively small batches. Pieces of glass

used the image of light emitted from stained glass in the famous Gothic cathedral to convey this. Esmerelda, the Gypsy girl, has a near conversion when she finds herself unexpectedly bathed in the colored light patterns from the windows. Likewise, set designers evoke the church by using images of stained glass in even the most minimal designs, from films and

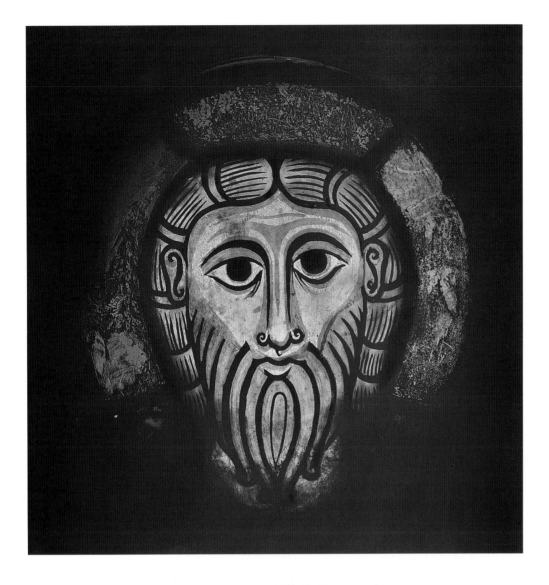

Head of Christ

Wissembourg Abbey, Alsace,
eleventh century; painted glass;
d. 9⅞ in. (25.1 cm). Musée
de l'Oeuvre de Notre Dame,
Strasbourg, France.

The design of this early head was achieved by painting the entire surface of white glass with varying concentrations of brown enamel and then wiping away areas for highlights. The power of the image derives in part from the simplicity of the technique and the Romanesque tradition of bold, graphic expression.

The Angel of the Annunciation

Detail; VINCENZO FOPPA,
late fifteenth century;
colored and painted glass.
Cathedral of Milan, Italy.

An examination of the angel shows a spectacular combination of colored and painted glass: ruby red for Gabriel's garment; cobalt blue in the points of his wings; green for the palm leaf of greeting; and the use of silver stain for the head, hands, and borders of the robe.

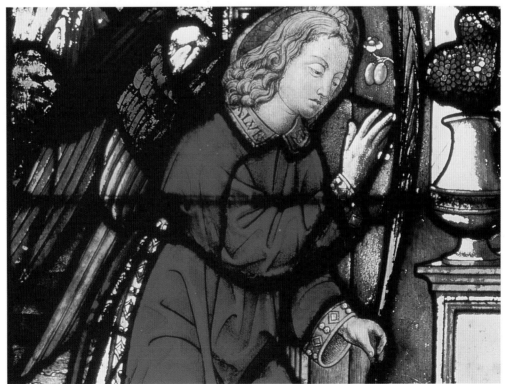

**Peacocks
and Peonies I**

*Detail; JOHN LA FARGE, 1882;
stained glass. National Museum of
American Art, Washington DC.*
La Farge frequently
used pressed, faceted, or
broken glass to create a
sparkling texture to his
stained glass designs.
This lunette from a do-
mestic window shows
the artist's mastery of the
decorative possibilities
inherent in the medium.

**Resurrection
of Christ**

*Detail; P. UCCELLO; stained
glass; Duomo, Florence.*
Enamel brown is
used—as with the
Weissembourg
head—to articulate
the details of the
soldier's face. This
later design, however,
shows a stylistic evolu-
tion towards a more
naturalistic rendering
of facial features.

were produced by means of a blowpipe using one of two methods, each of which began with a glob or "gather" of glass blown into a particular shape for further working. The first, which produced "muff glass," took pieces made from a glass cylinder detached from the blowpipe, then scored and flattened them while still hot. "Crown glass," made in the second method, began as spheres blown from the pipe. The side opposite the pipe was pierced, and the pipe was rapidly spun to flatten the glass by centrifugal force. Both methods were time-consuming, adding greatly to the cost of stained glass in the Middle Ages.

A single panel from the thirteenth century may be comprised of hundreds of individual pieces of glass. The glass pieces were usually small and often flawed, containing many impurities, bubbles, and irregular edges. These imperfections are among the special attractions of early medieval stained glass, and give it much of its characteristic radiance and color. Later, John La Farge and Tiffany introduced imperfections as a way to fracture the light and produce a jewel effect. Similarly, Frank Lloyd Wright always used "seeded glass," so named because it incorporates tiny bubbles that scatter the light, to create a vibrating quality.

In the Middle Ages, the full-scale drawing for the stained glass window or section was first outlined on an opaque, reflective surface such as a whitewashed board. Later, this was done on

paper. Pieces of glass were then fitted to this pattern. When this stage was completed, the individual pieces that required painted details were removed, and representational features like faces, hands, and ornamentation were painted. Medieval glaziers used an opaque enamel paint made of copper or iron oxide mixed with powdered glass and natural gum to bind the two. The painted glass was then fired in the kiln a second time to fuse the tones or details onto its surface.

The finished pieces were then fixed together and held in place by narrow, H-shaped lead channels, or "cames." This is also called the "leading." In the Romanesque period, windows could reach twenty feet (six meters) in height. Some thirteenth- and fourteenth-century windows—in St. Chapelle, for example—reach sixty feet (eighteen meters). To facilitate stability and installation, the large windows were subdivided into panels of no more than several square feet each and fixed to a gridlike armature that supported the weight of the panels from behind. On the interior side of the window, the panels were soldered to horizontal saddle bars to prevent forward slippage or buckling. In the early medieval period, there were considerable technical limitations affecting the size, quality, and range of colors of the glass pieces. These early stained glass artists, however, must be credited with miracles of the art that rank among the greatest and most sublime of all artistic creations.

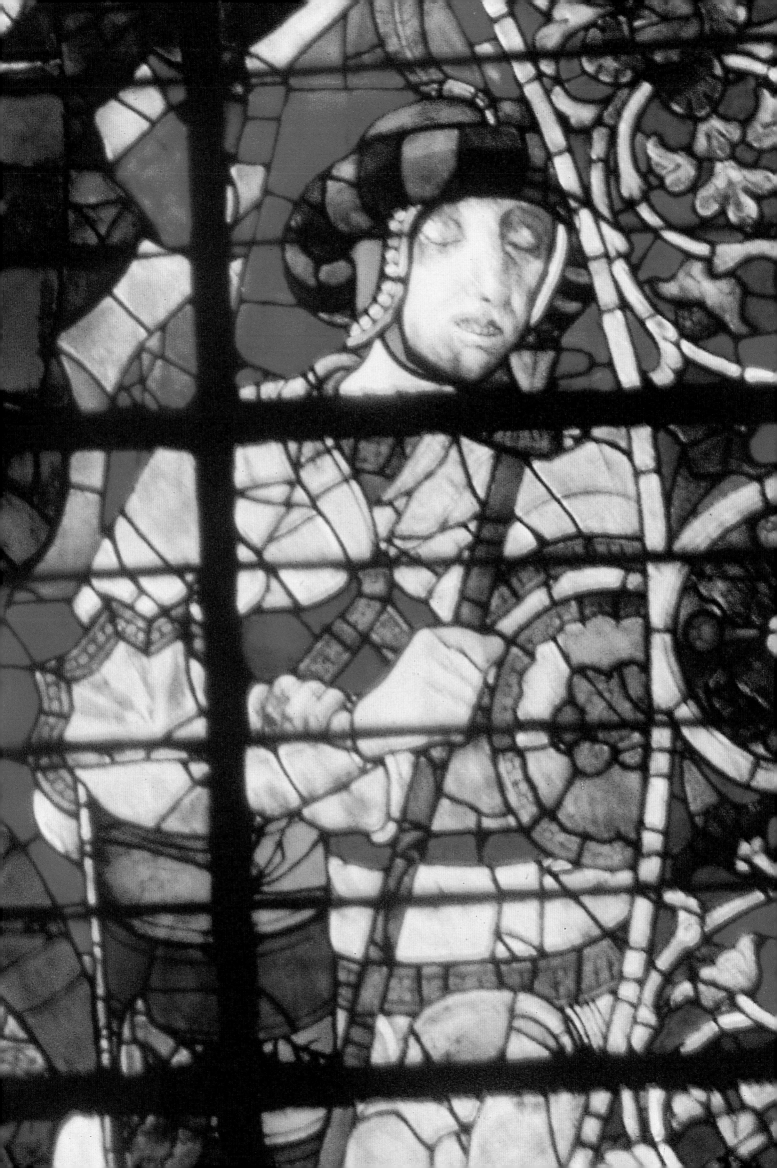

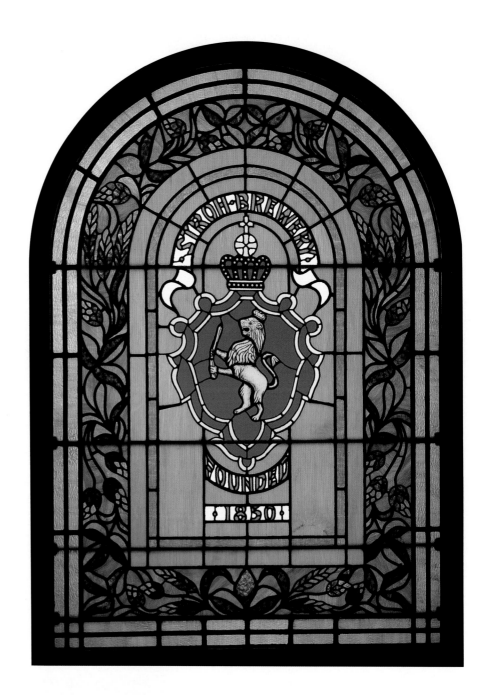

Stroh Brewery Window

Detroit Stained

Glass Works, c. 1914.

Milwaukee, Wisconsin.

Stained glass, with the weight of its historic associations behind it, continues to serve commercial, religious, and civic purposes, from breweries, churches, and synagogues, to colleges and government buildings.

Dome, National Portrait Gallery

Smithsonian Institute,

Washington DC.

Revived as a viable decorative element by William Morris and others, stained glass in public and domestic settings proliferated through new glass-producing technologies and engineering breakthroughs.

TECHNICAL AND AESTHETIC EVOLUTION

As time passed, glass production techniques became more sophisticated and were accompanied by changes in design. The production of suitable glass, of course, was always of greatest concern for the stained glass maker. In the early Gothic period, glass was produced at the building site as part of the same extended enterprise that made the windows. By at least 1300, glassmaking shops were established closer to the forested areas that provided the essential potash. A separation arose between those who produced the glass itself and those who worked it into the patterns and designs of windows. As a result of this

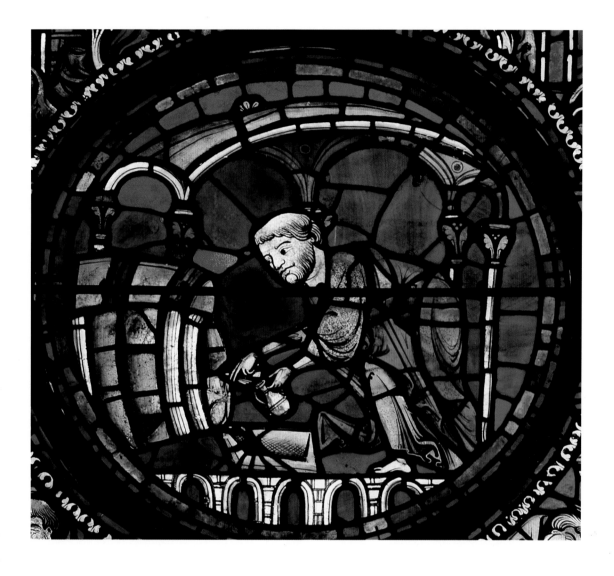

Wine Merchant

Detail from The Story of Saint Lubin *window, Chartres Cathedral, thirteenth century.* Chartres, France.

Endlessly adaptable, stained glass has been used since its beginning for secular as well as religious purposes. This window shows a wine seller at an inn and the common practice of vending wine within the cathedral nave.

specialization, the quality and size of both colored and white glass improved. The panes were thinner, more even in thickness, and freer of impurities.

By the late Gothic period, the coloring process also extended to the application of silver oxide or nitrate as a superficial staining agent to selected areas of a single piece of glass. Leading was no longer needed around the separate, variously colored, pieces. With the lead channels not reinforcing the main lines of the image, the synthesis of design and technique marking early stained glass began to be replaced by the more purely pictorial approach that culminated in the windows of the Renaissance.

The nineteenth-century revival of stained glass remains one of the more remarkable phenomena in art history. The rebirth of glassmaking and coloring processes by William Morris and other revivalists led to later experimentation by others. Stained glass, once again used on an architectural scale, was restored in the late nineteenth and early twentieth centuries to a fully developed artistic medium. In the relatively short span of time since then, the medium has been taken down paths unimaginable to those responsible for the revival. Stained glass today shows most of the essential qualities of its long and illustrious past, yet it is no longer bound to that past.

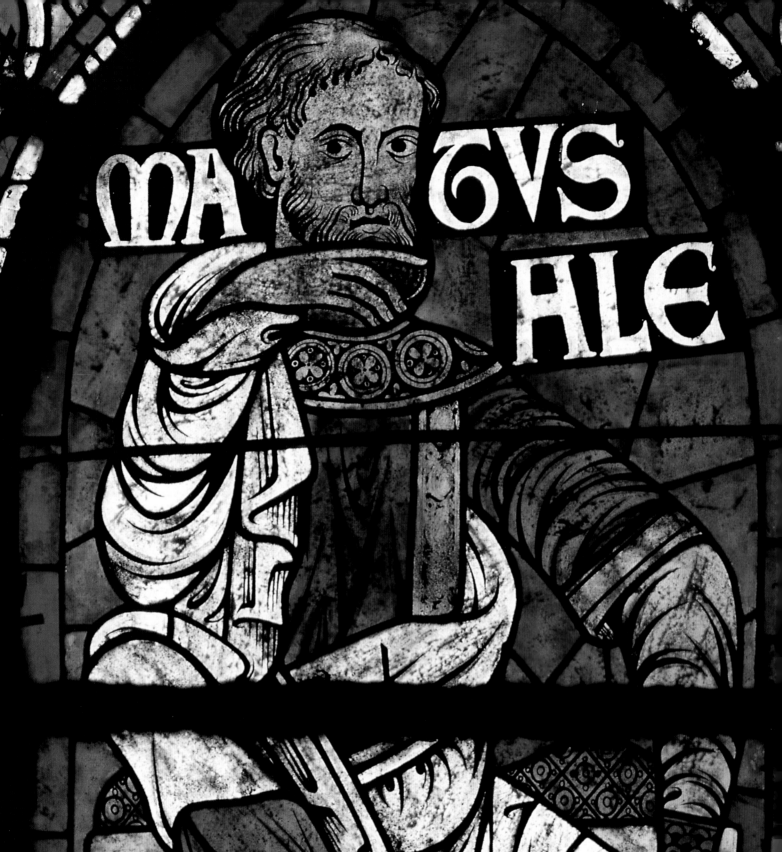

CHAPTER ONE

GOTHIC STAINED GLASS

THE DUALITY OF LIGHT AND STORY

The development of stained glass in the Gothic period is preceded by a long and poorly documented history, but the few fragments surviving from the sixth through eleventh centuries suggest a proficient and stable tradition for the medium.

In the new form, the opaque, static pictorial art of antiquity was transformed into imagery charged with the activating principle of light. The luminous quality of early stained glass corresponded to the metaphysical concepts of light and spirituality developed by early Christian theologians. Stained glass was seen as a mediator between the earthly and divine realms. The aura of colored light was easily interpreted as a metaphorical manifestation of divine strength and love. Sacred subjects drawn upon the glass were enclosed within the aura of the radiant, all-pervading light of heaven. No medium had yet linked so completely for viewers the representation of an image or story with what they felt was the sublime source of meaning for the story.

ROMANESQUE STAINED GLASS: C. 1050–1150

Depending upon an architectural context for its development, stained glass would not become a prominent artistic medium until the traditional design of churches was radically rethought in the late Romanesque period. It is probably not coincidental that no intact example of stained glass survives from earlier than the eleventh century, which was when newly emerging cultural and theological circumstances favored the growth of the art. During this age, the ground was laid for the sweeping cultural and intellectual changes that would usher Europe out of the lethargic Dark Ages into a great expansion of consciousness. To contemporary observers, such as the Cluniac monk Raoul Glaber, it seemed as though the world was remaking itself. The monastic reform movement stabilized and reinvigorated a lagging faith within the Catholic Church. The expansion of trade routes and the extension of local pilgrimage roads created a vast network connecting all parts of western and central Europe.

The oldest surviving example of stained glass from the Romanesque period is the striking and enigmatic head of Christ from the Abbey of Weissembourg, near Alsace. The head is painted on clear, or white, glass. The strongly linear image is painted with opaque brown enamel. Diluted concentrations of the same substance are used for the shaded areas. The fragment is now surrounded by later colored forms, and is from the mid to late eleventh century. Nothing is known of the original placement of the work. It may have represented a figure of Christ enthroned in heaven. Its highly stylized, Byzantine iconic effect may have been a major focus of devotion in the abbey church.

Between the tantalizing Wissembourg head and the next surviving work of stained glass lies a considerable amount of time. A group of four prophets from Augsburg Cathedral survives out of a larger series dating from the late eleventh or early twelfth century. The figures are largely intact and are the earliest known examples of

Methuselah

Detail from Methusaleh *and Lamech,* Christ's Church; *Canterbury, England.* The designer of this figure miraculously imbues the elegant stylizations of late Romanesque imagery with a shallow dynamism that moves from the physical tension of the body to the powerfully introspective spiritual faculties of the head.

The Prophets Hosea, Jonah, Isaiah, and Daniel
(left to right)

Clerestroy windows of nave, south side, Cathedral of Saint Mary; early twelfth century; Augsburg, Germany.

The oldest surviving evidence of the richly colored effects typi-
fying medieval stained glass. This extant series of four Old Testament
prophets was transferred to the present cathedral from its predecessor.
It is already technically assured and probably bears the fruit of many
years of development.

19

colored, painted, and leaded glass. They reflect the influence of manuscript illuminations and may have been produced by the abbey at Tegernsee, near Switzerland. The technical polish of the figures implies a previous period of development that may have extended as far back as Carolingian times, c. 750–850.

Though stained glass was undoubtedly in wide use by this time, the pieces that have survived suggest the evolution of medieval stained glass lay much more with cathedrals than with abbeys. The function of the cathedral was profoundly different from that of the abbey. By the twelfth century, cathedrals, located in town, were the focus of everyday community life. Abbeys were often isolated in rural areas and exclusively focused on the devotional duties of their monastic populations.

Throughout the twelfth century, a second wave of Romanesque church building began that primarily involved the construction of cathedrals. Romanesque stained glass reached its peak with the changing designs of ecclesiastical architecture in the twelfth century. The oldest surviving stained glass of this period comes from Le Mans Cathedral in western France. The lively, gesticulating figures in the *Ascension of Christ* are typical of the art of this region from around 1130, and they contrast sharply with the static arrangement of the Augsburg prophets. Within a generation or so, Romanesque art was clearly beginning to surpass the boundaries of rigid formalization to explore a more organic approach to depicting the human body.

In churches designed or constructed after 1130 or so, such as the cathedrals at Chartres and Poitiers, the heavy structure was pierced by unusually large windows. The typical ensemble—set in the principal positions of the west or east end—is a triad of windows symbolizing the Holy Trinity. The west windows of Chartres represent Christ's life and suffering as well as his earthly lineage. At Poitiers, the focal point of the massive apse wall is a twenty-foot-high stained glass image of the *Crucifixion and Resurrection* (c. 1160) that is flanked by windows telling the story of saints Peter and Paul. Compared to earlier pilgrimage churches, the windows featured pale accents of color where once there was whitewashed austerity. Vivid references to Christ's sacrifice and the means of man's salvation were made. The theological interpretation of a church transformed by light and color into a vision of the New Jerusalem, so characteristic of Gothic cathedrals, received its first tentative visual expression by the mid-twelfth century.

ABBOT SUGER AND THE ORIGIN OF THE GOTHIC STYLE

The first signs of a completely new visualization of spiritual subjects dramatically emerged in 1144, when the new *chevet*, or apse, of the royal abbey church of St. Denis was consecrated by the remarkable Abbot Suger. Within the freely circulating space of the ambulatory and chapels, light and color played a new role in the experience of the "divine realm."

Mary and Apostles

Ascension window, Cathedral of St. Julien; c. 1145; 66⅛ x 45⅝ in. (1.68 x 1.16 m). Le Mans, France.

The Ascension still lingers within the bold stylizations of the late Romanesque period. The static, symmetrical composition and the lively, gesticulating figures strike a perfect balance between intellectual order and the passions of the spirit. Seen is the new, early medieval attitude to devotion and faith, in which austere, meditative piety is rewarded with an ecstatic visionary experience.

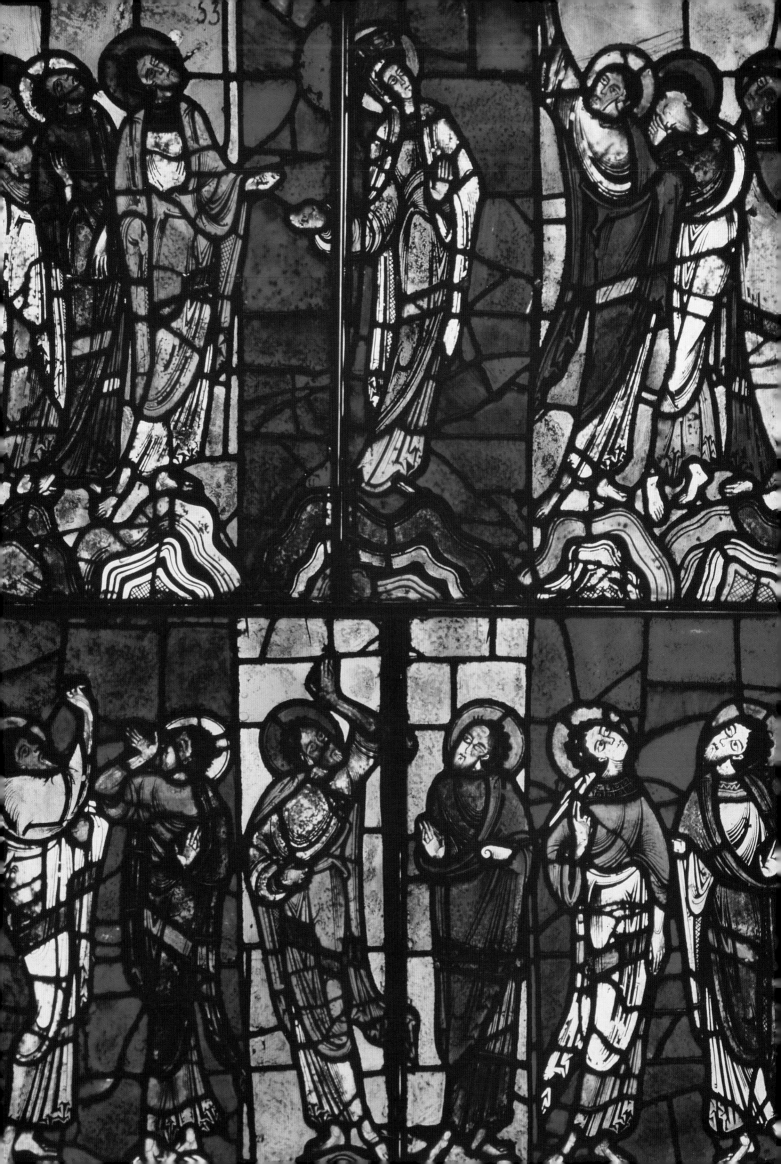

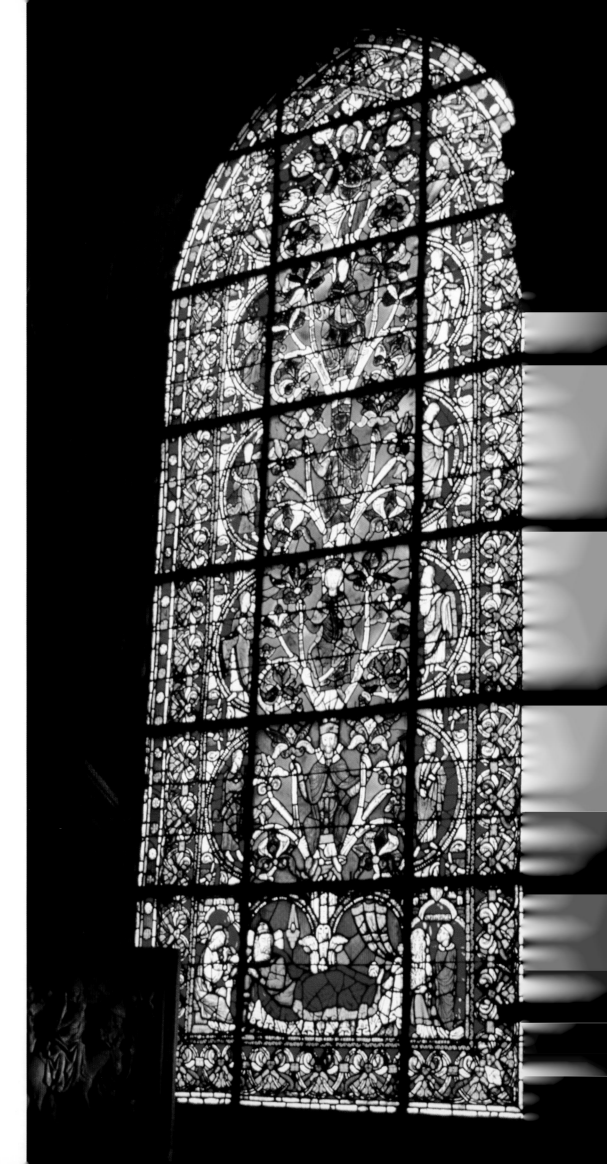

The Jesse Tree

Clerestory, chevet, Abbey of Saint

Denis, c. 1140. Paris, France.

The conception of the
earthly lineage of Christ
in the literal form of a
tree proved to be one
of the most profoundly
fertile creations of the
Gothic period. The
influence of Suger's
monumental adaptation
of the Jesse Tree theme
reflects a new spirit
of humanity and acces-
sibility to Christ
through Mary which
transformed Christian-
ity and the interiors
of its houses of worship.

The St. Denis windows were badly damaged during the French Revolution, but enough remains to reveal their exceptional achievement. The program presented the lives of certain saints, of Mary and Christ, of their ancestral lineage, and perhaps of the First Crusade and the story of Charlemagne. In these majestic windows, the spirit of Romanesque art was transformed, and the first steps were taken toward the Gothic style.

The window area holds a series of vertically arranged stained glass roundels, or medallions. In each medallion, a key episode of the story is depicted with a vivacious rhythm and liveliness lacking in the more statically fixed character of Romanesque art. The compositions are ordered with an architectonic clarity bestowing a new sense of volume and monumentality to the scenes. The color scheme is complex, and the use of overlapping figures creates a primitive but still evident depth of field. The subjects are presented with a new sense of visual and psychological experience. There is a striking emphasis on earthly life, giving the scenes a vivid reality. The medallions in the *Life of Christ* window, for example, stress Christ's humanity and therefore underscore the weight of his sacrifice.

Suger's invention of the historiated medallion window profoundly influenced the treatment of narrative subjects in stained glass for the next half century. The depiction of sacred themes as a logical sequence of momentous events reflects a major shift in the exposition of religious imagery in stained glass. Windows became the equivalent of visual texts explicating the earthly experiences of Christianity's sacred figures. At St. Denis, stained glass, which had long been the bearer of images and colored light, took on another role. Familiar presences were assigned to the sacred events shimmering within each window. Rather than look up at an awesome, huge vision of the Crucifixion, as seen looming in the apse of Poitiers Cathedral, the faithful at St. Denis experienced Christianity more intimately, with the familiarity of their own lives. Installed in a regular series along the wall, the

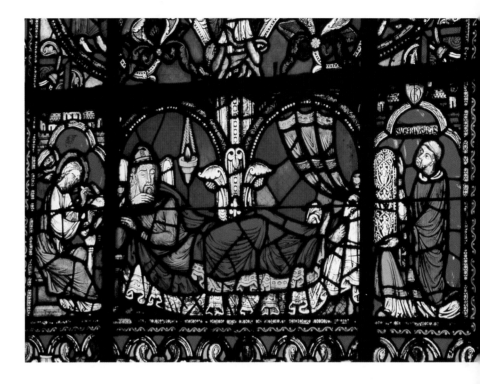

windows embody the history of the faith within the physical structure of the church.

In the ambulatory at St. Denis, light and color mingle splendidly. Revolutionary structural innovations allowed for more windows and stained glass to be included. The pointed arch and ribbed vaults eliminated walls between the supporting columns. These areas were then given over to windows. For the faithful, Abbot Suger had accomplished the impossible: he had found a way to combine divine illumination with natural light. For Suger, the abbey's interior transported him to "a position somewhere between the glory of heaven and the slime of the earth."

The impact of Suger's tour de force at St. Denis was immediate. Within a generation, his early version of a "royal style" would bring Romanesque architecture and pictorial art to the threshold of the style now known as Gothic. Early Gothic stained glass must be considered as a phenomenon that radiated out from the associated projects of St. Denis and the west front windows of Chartres Cathedral to embrace other cathedral centers in France, England, and, ultimately, Germany.

The Jesse Tree

Detail of base of window, with Jesse flanked by Matthew and Abbot Suger as donor; clerestory, chevet, Abbey of Saint Denis, c. 1140. Paris, France.

This window reflects the scholarly nature of Suger's program. The lamp and drawn curtain refer to the enlightenment of prophecy, while the evangelist Matthew writes his list of generations of the ancestors of Christ, who populate the tree above. Jesse's pose, with his legs crossed and torso elegantly turned to the left, reflects classical models.

Christ as the Flower of the Jesse Tree

Detail, apse, St. Kunibert Cathedral; c. 1220–30. Cologne, Germany.

The strongly linear character and the suppressed effects of the composition's volume and space reflect a supremely rational guiding intellect. The use of color is largely decorative, while the calligraphic style reflects the continuing influence of the superbly balanced, classicizing enamel plaques of Nicholas of Verdun. The great artist had created a reliquary for the cathedral of Cologne in the late twelfth century, and it is certain that the designer of this window was aware of this masterpiece or a related work.

The Life of Christ
(left and center windows)
**and the Jesse
Tree** *(right)*

*Inner façade of west front of
Chartres Cathedral; mid-twelfth
century. Chartres, France.*

The themes of Mary and
Christ stressed by Suger at
St. Denis are here given
a more popular narrative
flavor. The same shop may
have produced both works,
but at Chartres a luminous
tapestry of repeated colors
and pictorial fields imparts
a uniquely precious density
of design and content set
in the still Romanesque
façade of the cathedral.

THE TRANSITION TO THE GOTHIC STYLE: 1150–1200

Alternatives to the Romanesque style continued
to develop in both France and England for the
rest of the century. The three large windows of
the west façade of Chartres Cathedral, which
are late Romanesque in style, were glazed
c. 1145–50. Still surviving and in good condi-
tion, they are remarkably similar to those at
St. Denis and were probably made by the same
shop. Almost certainly, these artists continued
their work in the nave and apse of the cathedral,
which burned in 1194. A growing circle of
glaziers had meanwhile adopted the "St. Denis
style" and were active at other sites in France
and England, where work began at York
Cathedral around the mid-twelfth century.

The first opportunity for glaziers to develop
their work in a full-scale Gothic setting was
afforded by the new construction of Notre
Dame in Paris and at Canterbury. The old
Norman choir at Canterbury burned in 1174

and was rebuilt in an idiosyncratic but majestic
early Gothic style. In two campaigns at Canter-
bury (c. 1178–1206 and 1213–1220), Trinity
Chapel's choir, apse, and shrine of Thomas à
Becket (c. 1118–1170) all received large, mag-
nificently historiated windows.

For the shrine, the artists, who were prob-
ably both French and English, created the
first narrative representations in medieval art
of contemporary events. Becket had been
murdered in 1170, and a detailed record of his
posthumous miracles had been kept by the
monastery at Canterbury. Within a decade,
these accounts began to be translated into
visual form in the windows of Trinity Chapel.
The windows recount his life, murder, and
miracles with a subtly balanced synthesis of
figures and environment. At Canterbury, the
non-naturalistic conventions of Romanesque
art were breached and replaced by the mod-
ern formal concept of a unified pictorial
composition.

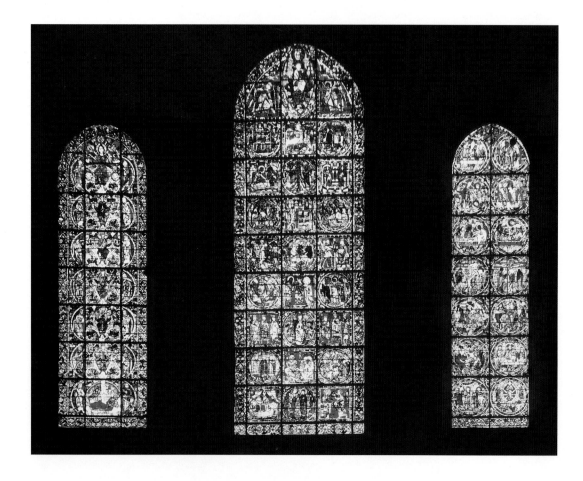

**Notre Dame de
la Belle Verriere
(Madonna
and Child)**

*South choir ambulatory, Chartres
Cathedral; mid-twelfth century; 193 x 93
in. (4.90 x 2.36 m). Chartres, France.*

This immense, imposing
image of Mary and Child
must have occupied a key
place in the Romanesque
version of Chartres, which
burned in 1194. Mary is
represented in her roles
as Queen of Heaven and
loving protector of
humanity. The slight tilt
of Mary's head wrests the
Byzantine origin of the
composition into contact
with the everyday con-
cerns of her adherents.

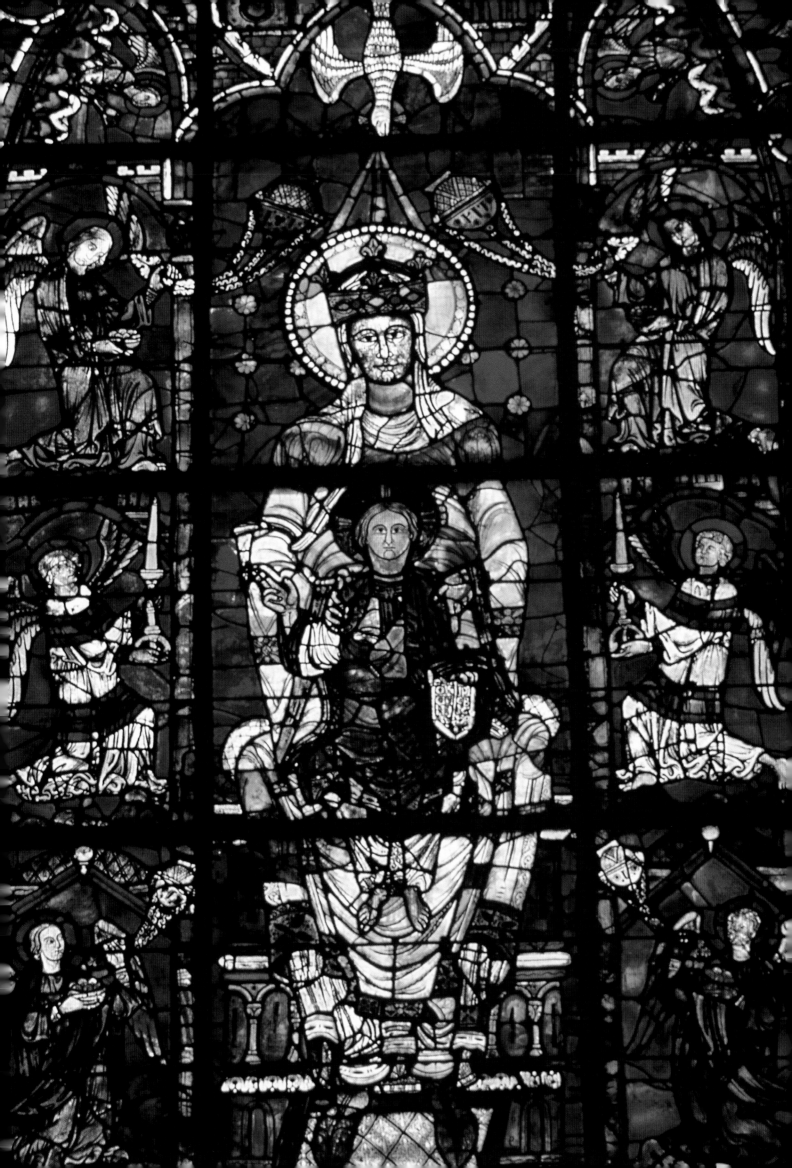

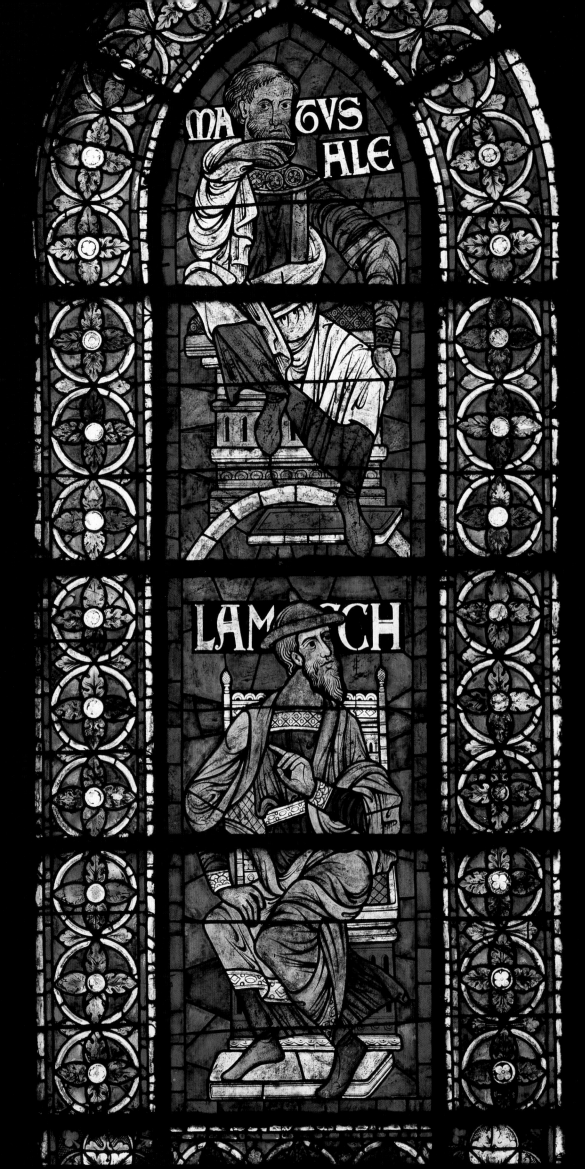

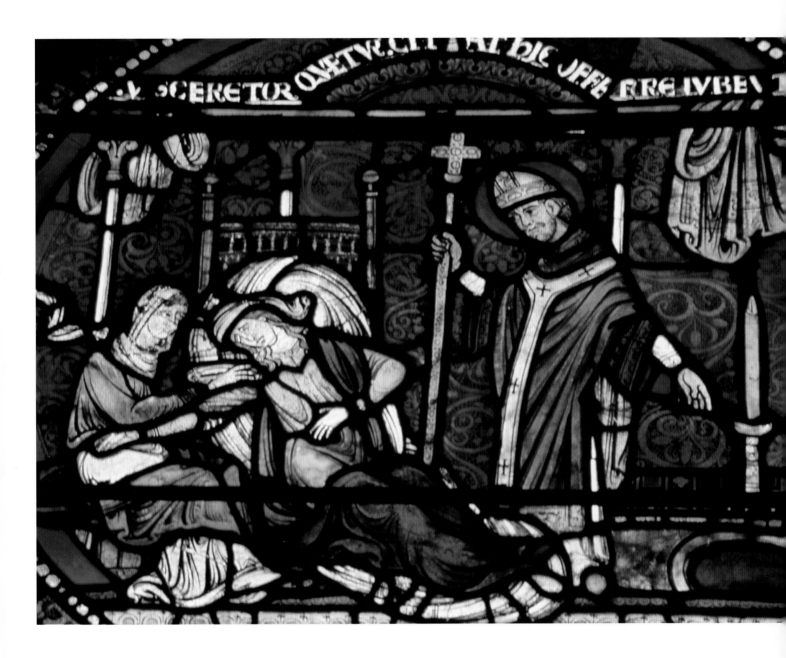

Miracles of Thomas à Becket

Trinity Chapel, Christ's Church Cathedral; c. 1190–1220. Canterbury, England.

In the Becket windows, made for the shrine of the murdered archbishop, the posthumous miracles of the saint reveal an unprecedented concern with the human reactions of those who benefitted from his intervention in their lives. A noble, nearly classical character balances an almost candid aspect of reportage. This scene was executed by a member of the workshop who developed a precocious conception of dramatic pose and compositional massing.

Methuselah and Lamech

Choir clerestory window, Christ's Church; c. 1178–80. Canterbury, England.

Placed one over the other, these figures once formed part of a series of forty-two pairs of ancestors of Christ that lined the upper windows of the choir. Methuselah in particular reflects a mood of genuine thought, as late Romanesque figural conventions yield to a more organic conception of the human form.

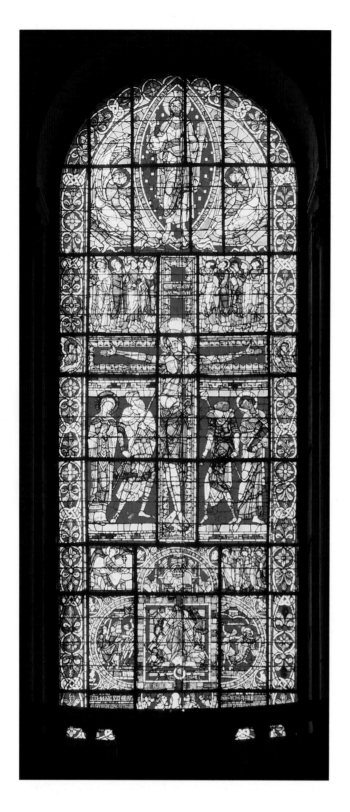

The Crucifixion and Ascension of Christ

Poitiers Cathedral, late twelfth century. Poitiers, France.

Many stained-glass windows incorporate multiple scenes to create
a multi-layered narrative. Starting from bottom with the Crucifix-
ion, the story moves upwards, showing the death and finally the
Ressurection of Christ in the top panel.

THE GOTHIC CATHEDRAL: 1200–1250

The rise of the great French Gothic cathedrals took place in one of the most varied and dynamic eras of western civilization. The emergence of a secular world in some ways comparable to modern times was well under way. The period's spiritual side, however, remained strong and vibrant. Thomas Aquinas, preceded by the defiantly independent Peter Abelard, attained the ultimate synthesis of faith and reason through his study of Aristotle's logical methods of argument. The essence of God's intelligence was felt to be thus brought down from heaven and bestowed upon humankind. A related, but even more potent force, was the veneration of Mary as the Mother of Christ. Mary came to be considered as a spiritual force in her own right, as the ever sympathetic and loving universal mother. The increasingly secular nature of the arts in the Gothic period can be explained as much by the profound humanity of the Marian cult as by the intellectualism of Aquinas. Mary appears countless times and in many guises in medieval art. Above all, her importance is emphasized by the nearly universal dedication of the Gothic cathedrals to her as the Queen of Heaven.

Most of the great Gothic cathedrals were begun, and many completed, during the first half of the thirteenth century. With many surviving to the present day, they have endured as the ultimate form of the cathedral in the popular imagination. Gothic architecture represents an entirely different constructional concept than the ponderous, earthbound structures of the Romanesque style. By the late twelfth century, the cathedral had been transformed into a structure borne not by solid walls but primarily by sequences of vertical piers, pointed arches, and ribbed vaults. Supported externally by graceful buttressing, the upper levels of the church between the piers could be left open and not be crowded with supports. For the first time in western ecclesiastical architecture, light became a major component of the interior. The logical

understanding of structure and the relationship between wall and window would revolutionize and dominate the architecture of northern Europe for the next three centuries. The Gothic cathedral uses carefully modulated light to foster a dynamic, typically medieval synthesis of the spiritual and the secular. Earthbound, with the conflicts of good and evil always present, the Gothic church nonetheless soars upward to present a vision of unearthly splendor.

Ressurrection of Christ

P. UCELLO; stained glass; Duomo, Florence.

Rendered with particular attention to facial detail, the subtle expressions on the faces of Christ and the two soldiers are achieved through the use of brown enamel paint. Such painterly effects were first applied to stained glass during the early Gothic period.

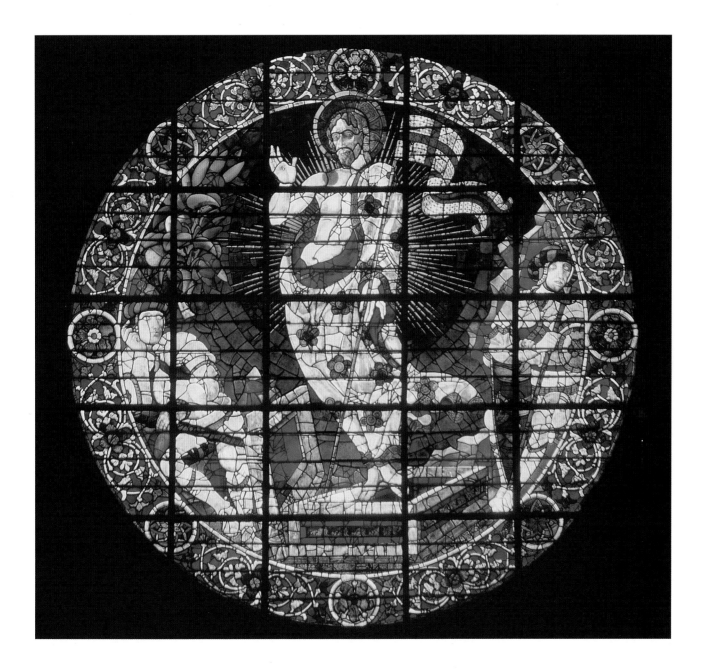

CHARTRES CATHEDRAL

The oldest major example of fully developed Gothic architecture is Chartres Cathedral. After a fire in 1194 destroyed all but the west front of the building, reconstruction began almost immediately and continued unabated until the new church was nearly finished in 1220. Unlike at St. Denis or Canterbury, there were at Chartres few Romanesque parts left to compromise the new outlook for the religious art of the future. The oldest windows of the new cathedral reveal a sophisticated classicism from which the first truly Gothic style would emerge. Related to contemporary currents of artistic expression as disparate as Byzantine art and the work of a metalworker, Nicholas of Verdun, the "1200 style" imparted a sense of organic cohesion to the pictorial elements. A wholly new path was opened in visual representation—with a clear narrative flow and a dignified sense of psychological presence to the figures—that mirrored the diverse cultural climate of the time.

At Chartres, the unrestrained power and majesty of stained glass in concert with the surrounding architecture can be fully appreciated. Chartres, and to a lesser extent Bourges Cathedral, still possesses most of its early-thirteenth-century glass. With the development of Gothic architecture on a large scale at Chartres, the first comprehensive consideration of the interior environment took place. Every part of the cathedral—façade, nave, transepts, and choir—is enriched by glowing images from the stained glass. By this time, Gothic architecture had not yet developed the openness of the wall to the point of its apparent disintegration,

Window of the Saints

Chatres Cathedral, twelfth–thirteenth century. Chartres, France.

The oldest major example of fully developed Gothic architecture, the Cathedral at Chartres still possesses much of its early-thirteenth century stained glass.

Chartres Cathedral, south transept

Rose window and lancets; c. 1234. Chartres, France.

The arrangement of these windows presents the theme of God's promise of salvation to mankind. In the rose window, the timeless, perfectly ordered universe is presided over at its center by a beneficent Christ. The entire scheme gives visual form to the intellectual definition of a cosmos that includes heaven and earth and is guided through all time by the loving compassion of its Creator.

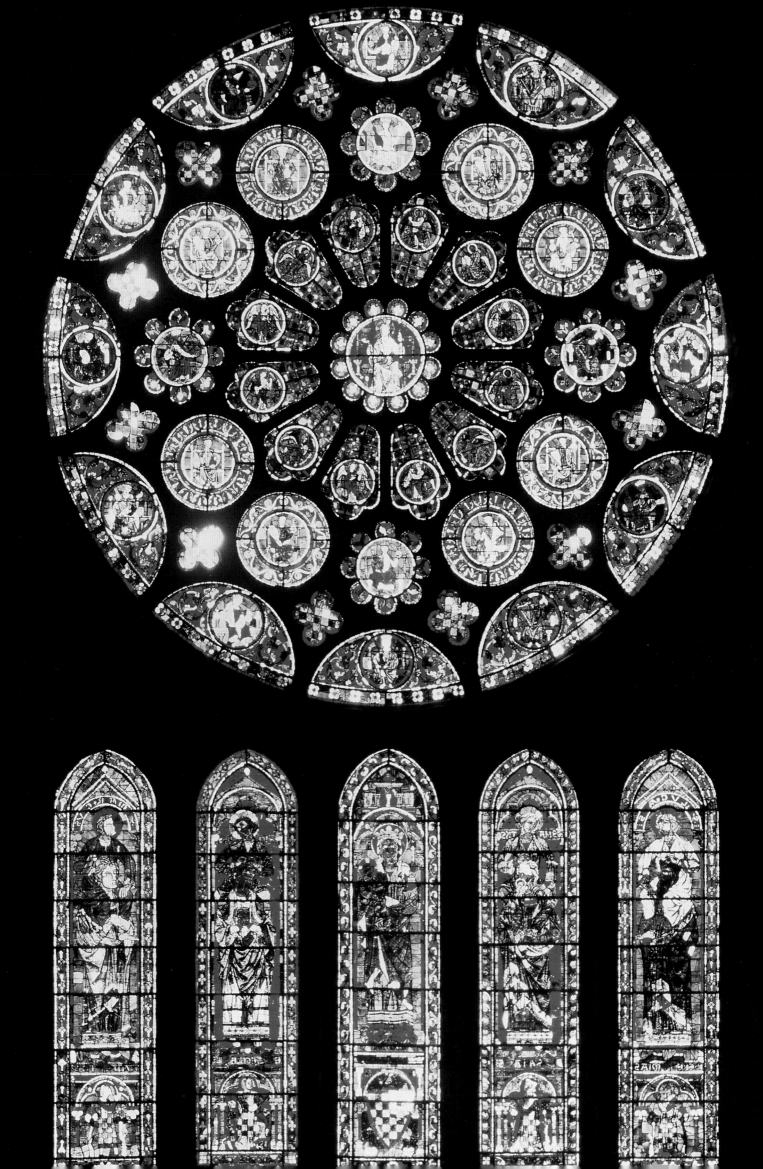

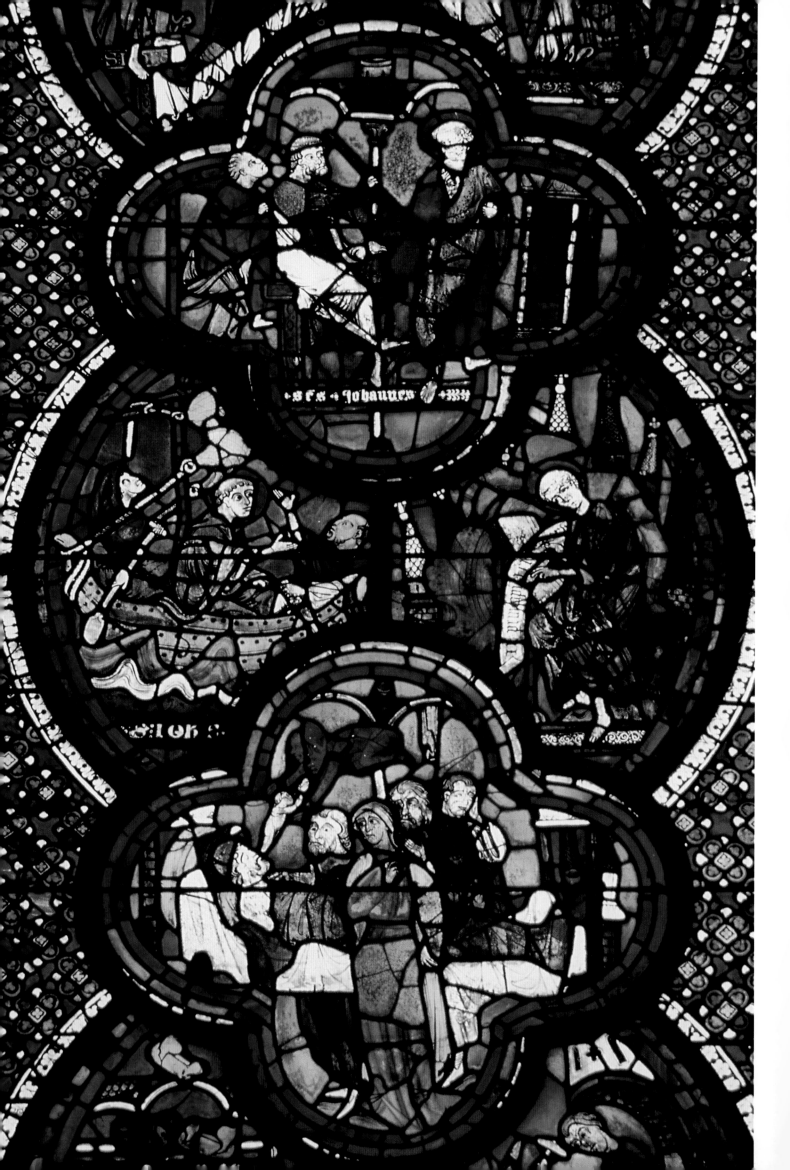

S Fx + Johannes +

so, as a result, the windows at Chartres punctuate the darkness of the interior with a remarkable intensity.

The windows at Chartres indicate a broad scheme of glazing that would be followed in all subsequent major cathedrals and churches designed according to the "cruciform" or "Latin cross" plan. The long side aisles, where a visitor could come fairly close to the windows and usually make out the images if the light was sufficiently strong, afforded much space for the exposition of narrative subjects. High above, in the clerestory of the main nave, windows of equal or larger size contain single images of the Christian tradition's holy figures.

The lower side aisle windows at Chartres contain a fascinating variety of themes, from *The Life of the Virgin* to *The Legend of Charlemagne*, which reflect the interests of the window's donors. Perhaps nowhere else in medieval art is there such compelling evidence for the dynamic quality of life in a commercial, urban setting. About one-third of the windows were paid for by the town guilds. Especially in these guild windows, the sacred and the profane meet and merge. The other windows were donated in roughly equal numbers by ecclesiastics and the royal house of France. Therefore, all levels of authority and occupation at Chartres were involved in the completion of a work still unsurpassed for its vibrant colors and large scale.

Among the chief glories of Chartres and many other cathedrals are the "rose windows." Chartres has three, one in the highest position in the west façade, and one at the end of each transept. These works are highly complex, both

Window of St. John the Evangelist

Nave, bay one, south aisle of Chartres Cathedral; c. 1205. Chartres, France.

The arrival of the early Gothic style is fully evident in the new urgency of expression in these scenes from the saint's life. The figures of the stories actually seem

The Death and Assumption of Mary

South aisle of nave, Chartres Cathedral; early thirteenth century. Chartres, France.

By the time of the reconstruction of Chartres Cathedral, beginning c. 1200, the early Gothic style had begun to be independent from Romanesque models. Within the orbit of the inspired narrative format of Suger's medallion windows, the scenes of Mary's progress from her earthly death to her

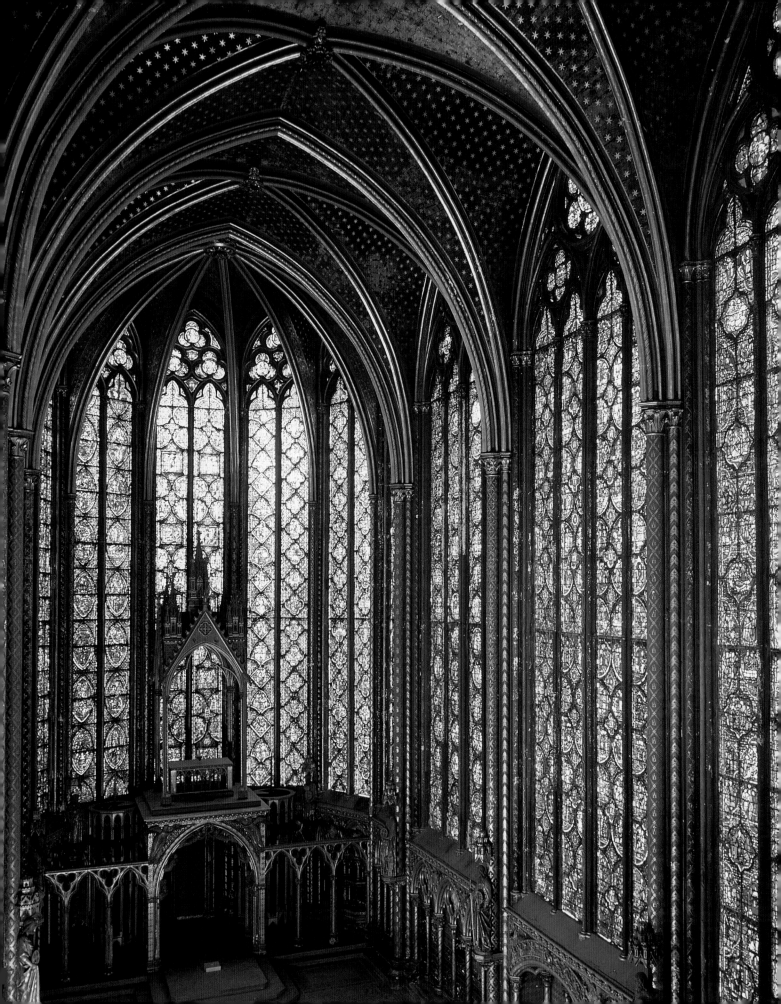

technically and symbolically. The subject depicted—usually Mary or Christ in heaven—is always at the center of a concentrically arranged series of symbols. The rose window may well represent the most appealing and sophisticated achievement of medieval spiritual exposition. Half-symbolic, half-material, these works were thought of as the "eyes of heaven," both for the literal light they admitted as well as for their explication of Christ and Mary's roles as disseminators of all knowledge and salvation. The rose window has been likened to the mandala, a sacred symbol of the cosmos. Embedded in the window are mathematical designs alluding to the harmony and purity of heaven. In these several ways, then, the rose window was to function as both a guide to holy wisdom and a path to salvation.

THE 'RAYONNANT STYLE' AND THE COURT OF PARIS

As the thirteenth century progressed, the French Gothic style matured, and several more major cathedrals, such as those at Bourges and Sens, received a full complement of stained glass. At the same time, a new force asserted itself to provide the main stylistic focus in art and architecture for the remainder of the century and beyond. In contrast to the itinerant shops of the cathedral projects, the royal court at Paris brought together and concentrated the efforts of France's greatest talents in the arts.

During the reign of King Louis IX (1220–1270), the delicate grace and surface refinement of small-scale metalwork and manuscript illumination was combined with the substantial breadth of form that had already appeared in the portal sculpture of the cathedrals. From this sustained creative environment, a single aesthetic of distilled refinement emerged. The characteristically French appreciation of art as a vital experience is first truly noticeable in the early thirteenth century.

In the French "court style," stained glass was given a finely wrought beauty and subtle chromatic harmony. The architectural context of the window changed dramatically, as architects aimed at the highest possible proportion of glazing to surrounding structure. In the choir of Amiens Cathedral, begun c. 1230, the refinement of external buttressing allowed windows of maximum size and height to be constructed. The thin, stone "bar" tracery, which fills the tops of the clerestory windows, is complex and highly ornate. The breathtaking unity of the naves in the period's cathedrals reflects a strongly linear system of harmonious proportions and vertical accentuation. Light takes on a ubiquitous, permeable quality as it penetrates glass within thin screens of stone tracery and supports.

The radiant quality of windows created during this period led to the use of the term *rayonnant* to describe the exhilarating treatment of light and color on a monumental scale. The dense,

Sainte-Chapelle, upper chapel

Probably PIERRE DE MONTREUIL, 1243–48. Paris, France.

In its own way, Sainte-Chapelle is as much a testament to the extent of French royal power and ambition of the High Gothic period as is Suger's apse at St. Denis created a century before. From the abbot's initial expression of a light-filled sacred space, the courtly art inspired by Louis IX, who commissioned the chapel, aspired to open the entire wall space of the structure. Subdued light and profuse imagery create an environment suiting the function of the chapel as a reliquary.

**Scenes from
the Life of
St. Stephen**

Detail of Potters' Window, *nave,
Cathedral of St. Etienne; early
thirteenth century. Bourges, France.*
By the early thirteenth
century, stained glass
artists had already
defined two major veins
of storytelling: an epic
mode, as at Chartres,
and the much more
intimate, fable-like
quality of many of the
windows at Bourges.

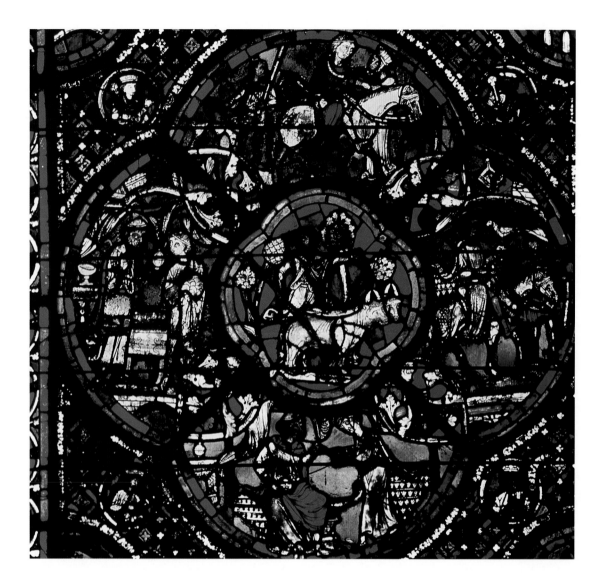

saturated red and blue colors of Chartres were replaced in rayonnant windows by lighter and less contrasting hues. Stained glass designers were integrally involved with these changes and dramatically altered the expressive possibilities of their medium to exploit the new window openings. Further, *grisaille*, a new form of glazing, was developed. Consisting primarily of a tonally restricted range of lightly colored glass, grisaille was often used around the darker, figurative areas to allow for the greater passage of light.

EUROPEAN GOTHIC STAINED GLASS: 1250–1300

The "rayonnant pictorial style" reflected the urbane, sophisticated culture of the royal court at Paris. This refinement of French Gothic stained glass resulted in a style that, like the new cathedral architecture itself, could be easily grasped beyond the land of its birth. From this point on, any history of stained glass must take into consideration the local variations of the Gothic style that soon appeared throughout Europe. The Gothic style spread quickly beyond

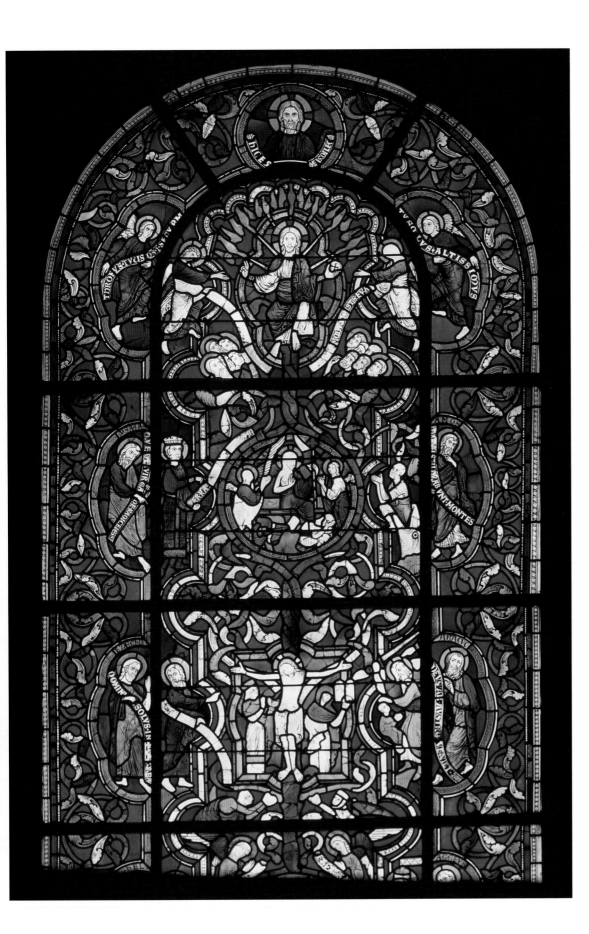

FOLLOWING PAGE:

Wells Cathedral, east window

Fourteenth century. Wells, England.

The treatment of the east end of the cathedral as a monumental screen of glass is a further contribution of the fourteenth century to the medium. The rhythmic amplification of the Jesse Tree within this space is ideally integrated with the vertical members of the supporting bar tracery, which is a splendid example of the decorated or reticulated style.

The Jesse Tree

Apse, St. Kunibert Cathedral, c. 1220–30; h. 207⅞ in. (5.28 m). Cologne, Germany.

The spread of the Gothic style beyond France engendered many local variations of style and theme. Cologne was an important commercial and pilgrimage town and became one of the great artistic centers of the Rhineland. In this example, a restless yet ordered linearity of form binds the entire composition of the rising Jesse Tree with its surrounding decorative motifs.

Joab Kills the General Amase

Saint Thomas Church, Strasbourg, c. 1270; stained glass; h. 24 3/4 inches (63.4

cm). Musée de l'Ouvre de Notre Dame, Strasbourg, France.

With rich, jewel-like colors and realistically rendered fig-
ures, this window illustrates a passage from the book of
Samual, in which Joan kills the general who betrayed King
David.

The Crucifixion of Christ

Detail, Pentecost window, Cathedral of St. Peter; c. 1270. Regensburg, Germany.

The gentle sway of the bodies, the subtle demonstration
of naturalistic anatomical detail, and the registration
of genuinely empathic emotion in the faces of Mary
and John reveal the onset of a fully Gothic style in Ger-
many. This direction would be pursued for at least two
hundred years in the many centers of the German states.

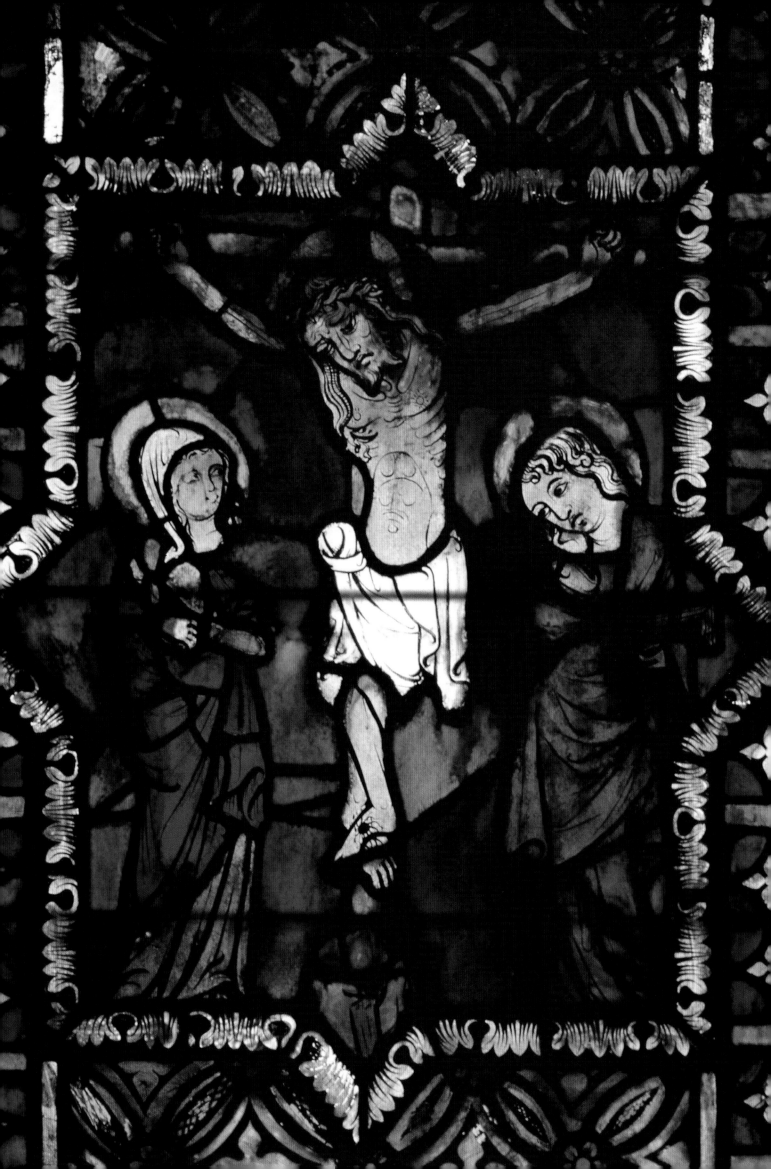

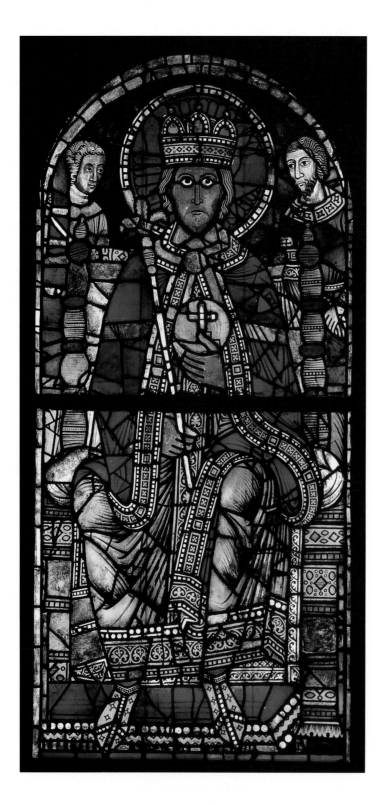

Philip of Swabia, Holy Roman Emperor

North nave, Strasbourg Cathedral; c.1275. Strasbourg, France.

By the late thirteenth century, images of temporal rulers appeared in the clerestory windows of cathedrals in addition to the customary figures of prophets and saints. Philip is depicted as a ruler in majesty, with obvious references made to the authority of Christ.

the borders of France to the Germanic lands, parts of central Europe, and northern Spain.

Throughout Europe in the latter half of the century, new compositional formats and design approaches further transformed the "cathedral style" of Gothic stained glass. Large-scale compositions were often spread across two or more window areas and increased use was made of grisaille glass. In general, late-thirteenth-century stained glass can be identified by the fact it allows more light into the cathedral and by its more decorative, flowing sense of surface design.

The height of clerestory windows, such as those at Strasbourg Cathedral, was further accentuated by vertical interior stone divisions, or "mullions." Figurative compositions were altered dramatically by this development. The use of historiated medallions to contain the narrative element was occasionally retained, but stained glass artists increasingly turned to a freer use of the great compositional expanse of the windows. It was as if the freedom of size encouraged a freedom of subject matter. Among the most dramatic and popular images were "canopy figures." The traditional subjects of prophets, kings, and saints was expanded to include royalty of more recent European history. Previously represented within modest, fictional architectural settings, these standing figures were now surmounted by towering, elaborately designed canopies in stained glass. Often, a single window accommodated two or more vertically arranged figures.

In the early fourteenth century, the court style at Paris assumed a lighter aesthetic of refined, abstract movement and self-consciously suave form. Inspired by antique sculpture, as cathedral statues had been a century earlier, the artisans used an exaggerated, S-curved pose for their figures, which transformed the organic structure of the body into an elegantly artificial image of grace and intimacy. Developments came from around Europe, and, though there were many vital local traditions, the art of this period became truly international in style.

Pentecost Window

Cathedral of St. Peter; c. 1270. Regensburg, Germany.

The stylized, non-organic treatment of the frames and filling ornament impart a precious, jewel-like quality to the structure of the window. The characterization of the scenes is likewise rigorously controlled. An idiosyncratic color sense juxtaposes broad areas of contrasting hues and values with the whole keyed to focal points of white.

Nursing Madonna

Central group from window of
Charles the Bad, Cathedral Notre-
Dame; Guillaume d'Harcourt,
c. 1330. Evreux, France.

The suppressed coloris-
tic harmonies of the
figures, executed in
grisaille (monochrome)
and silver stain, accentu-
ate the beautiful S-curve
of Mary's figure. French
art had long been head-
ing toward this degree
of rarified, artificial
elegance, and during
the first half of the four-
teenth century similar
treatments of the
courtly mother of Christ
appeared throughout
Europe and England.

St. Francis Heals a Cripple; St. Francis before the Crucifix of St. Damiano

San Francesco, upper church; late thirteenth century. Assisi, Italy.

The art of stained glass arrived late in Italy. The earliest windows date from the late thirteenth century and
were executed by German craftsmen. The iconography and Byzantine style of the St. Francis windows, how-
ever, reflect central Italian traditions, indicating that local artists may have contributed to the designs. The
later works demonstrate an entirely new attitude to space, form, and narrative first fully mastered by Giotto.
Almost as soon as stained glass was introduced to Italy, such developments began to redefined the medium.

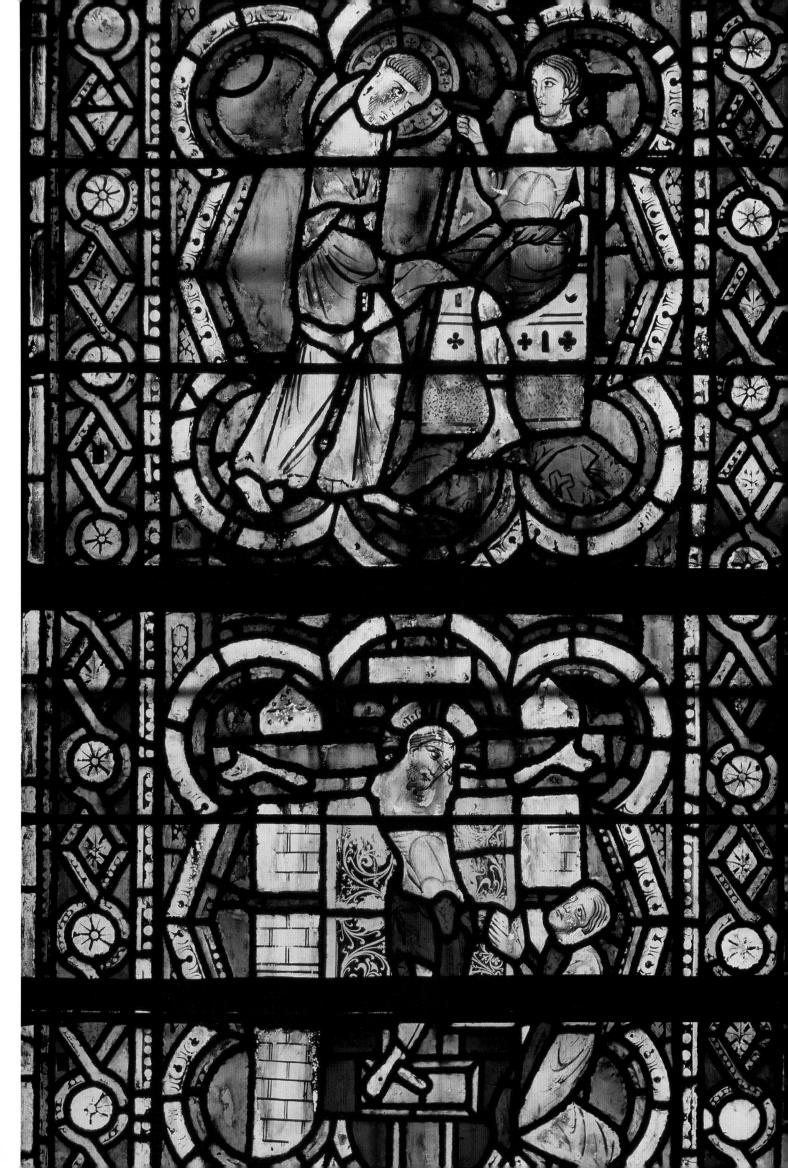

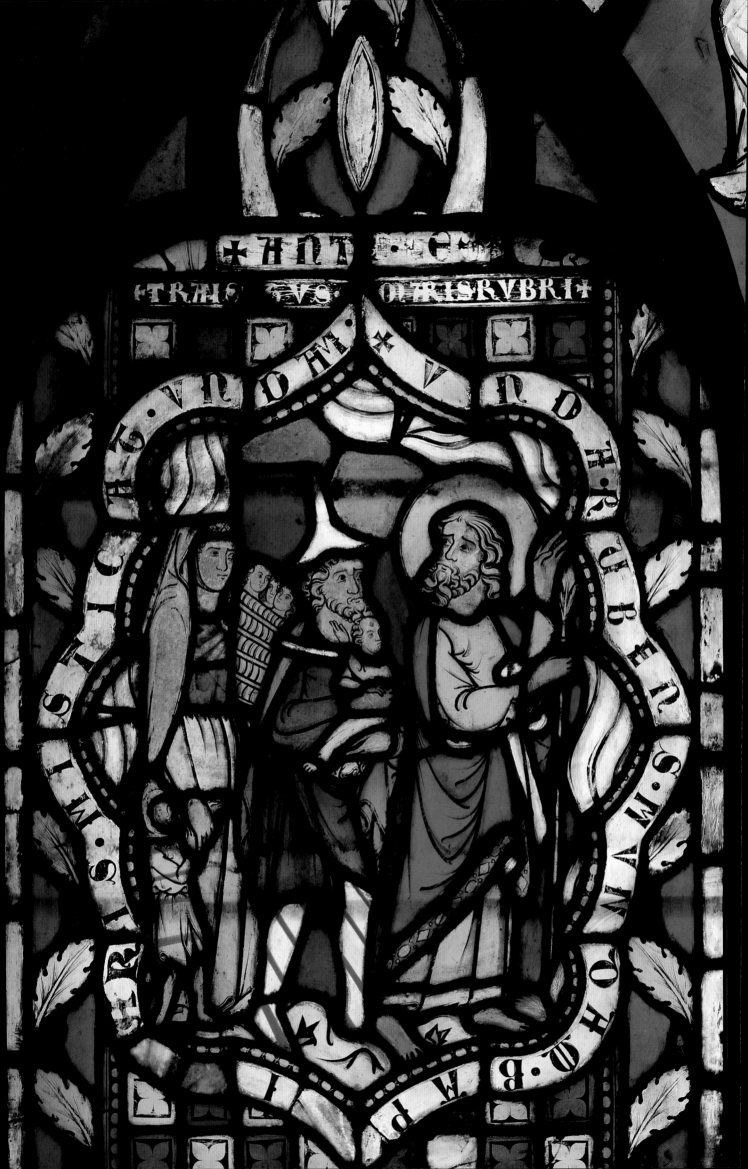

CHAPTER TWO

NEW HORIZONS OF THE RENAISSANCE

THE FOURTEENTH CENTURY: TRADITION AND EVOLUTION

The horrific events of the fourteenth century—including the Hundred Year's War between England and France and the Black Plague—were balanced by what has been thought of as the intellectual birth of modern Europe. By 1400, the perennial counterpoint between spiritual and secular concerns had decisively shifted to favor the secular.

As the century progressed, this situation was reflected in art through dramatic changes in style and technique. In northern Europe, a growing realism of form and scale developed. Fourteenth-century art took a crucial turn from representation by artificial convention to representation of the natural world. Visual artists deployed an entirely new, literal reference to the human experience of the world in their works. Italian painters developed linear perspective. The very nature of vision was addressed by artists everywhere.

Traditional stained glass techniques were refined as well. A new coloring agent, silver stain, was discovered that revolutionized the medium's technical and aesthetic evolution. For the first time, a distinct, high-keyed color could be directly painted on the glass. A thin application of the silver solution produced a range of colors extending from bright yellow to dusky orange, and it was often used to represent golden objects such as crowns. Reflected light—like that seen on tooled, gold-leaf backgrounds of late-Gothic panel paintings—partly accounts for the bright, decorative quality of details made with silver stain. The use of silver stain was to play a prominent role in stained glass design during the many phases of the late Gothic and Renaissance periods.

Stained glass remained a characteristically northern European art form after the Gothic period. After 1300, however, the arts of this region underwent a further transformation. The source of inspiration was Italy. In Rome and Florence, painters such as Giotto had revolutionized compositional organization and solid forms to imply in their works a surrounding expanse of space. As seen in the windows of the Franciscan convent church at Königsfelden, Switzerland, northern European artists successfully incorporated these lessons within their own, more closely descriptive, local styles.

By the early fourteenth century, northern artists were capable of a truly critical response to the vein of classicism that had run through art for more than a century. Near Vienna, an extremely sophisticated sense of rational form produced the remarkable windows at Klosterneuburg Abbey. One of the major influences was local. A renowned metalworker, Nicholas of Verdun, had built a reliquary at Klosterneuburg in the late twelfth century. His elegantly patterned designs for the reliquary's enameled plaques taught the

The Crossing of the Red Sea

Leopold Chapel, Abbey of the Augustinian Canons, c. 1330–35; 39 x 22⅞ in. (99 x 58.1 cm). Klosterneuberg, Austria.

As yet unaware of the revolutionary volumetric effects of Giotto and other Italian painters, the glaziers renovated their local traditions to impart a greater naturalism and unity of composition to the extraordinary windows at Klosterneuburg. Earlier formulas for facial and body types are brought to the threshold of a radically new attitude toward narrative design.

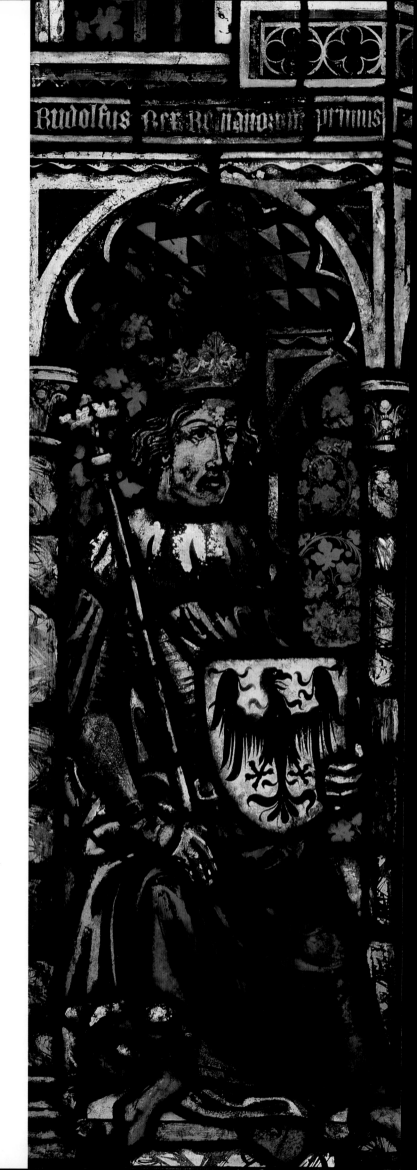

fourteenth-century glaziers how to keep a strong sense of linear tautness. Aware of the latest stylistic developments, the designers responsible for the Klosterneuberg panels made highly original creations that show they were receptive to diverse styles. This quality often characterizes a culture in transition.

On both sides of the Alps, the century closed with the refined harmony of the "international Gothic style." An equilibrium had been reached between northern descriptive realism and the use of illusion found in Italian art's space and form. The two modes of imagery were seamlessly joined by a highly developed decorative sense that recalled the official court art of France. In Germany of the 1430s, the windows of the Besserer Chapel in Ulm Minster were designed by Hans Acker with a superb grasp of decorative color and form. The northern Italian painter and manuscript illuminator Belbello da Pavia designed prophet figures and other images in a similarly intimate vein for the new Gothic cathedral of Milan.

Elsewhere in Italy and the north, however, the signs of rapid changes in the arts were already manifest. The precocious realism of French and Burgundian manuscripts was further developed in panel painting, a medium that had been little practiced in the north before. Painters of the first rank transformed the international Gothic style's precious mannerism into an urbane reflection of the social milieu of the emerging burgher class. In Italy, meanwhile, the

King Rudolph I *(left)*, **King Albrecht I** *(center)*, **and King Friedrich I** *(right)*

From the Hapsburg windows at St. Stephen's Cathedral,

c. 1390; h. 8 ft (2.44 m). Historisches Museum, Vienna, Austria.

The canopied monarchs are rendered with a precious design typical of the fin de siècle courtly style of northern Europe. Stained glass ideally preserved the sense of jewel-like ornament and formal pomp beloved by noble society both north and south of the Alps.

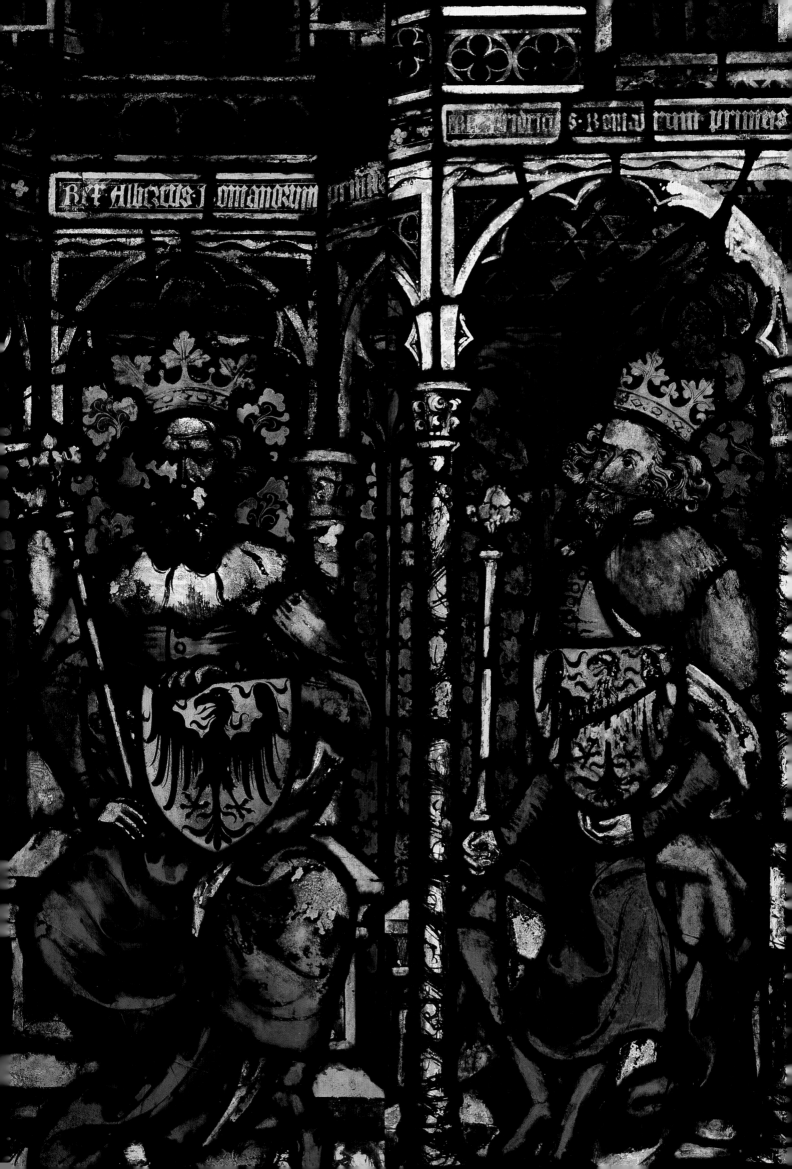

Rex Albertus Romanorum primus

Alexandria · s· Bonaventura primas

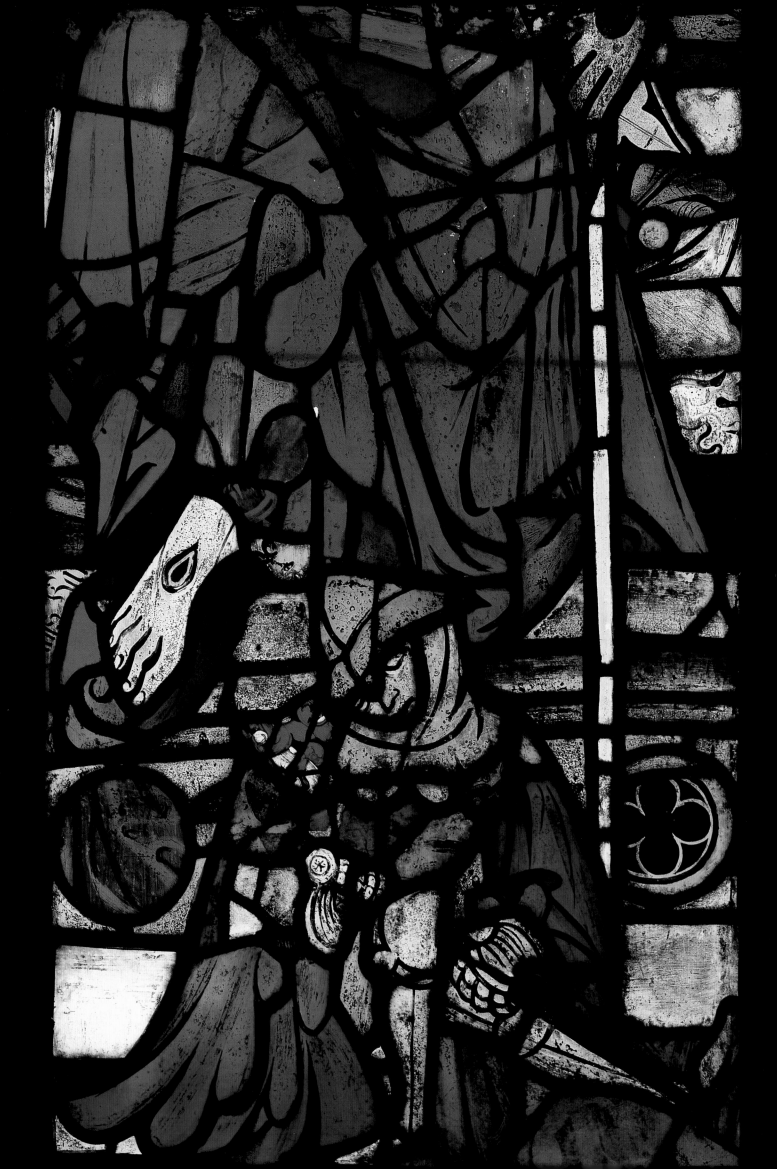

analogy between vision and the painter's art was integrated with an intellectual concern for pictorial structure. When international Gothic style waned, European Renaissance art no longer had so evident a common ground and thereafter followed two paths. It was not until the beginning of the sixteenth century that the two traditions—northern realism and southern classicism—once again found a strongly unifying force in the universal appeal of the High Renaissance.

INNOVATION IN THE EARLY RENAISSANCE: 1400–1500

The development and production of Renaissance stained glass is much more fully understood than is its Romanesque and Gothic predecessors. The designs for early stained glass cannot be positively attributed. Whether we are to credit the master glazier or a practitioner of another art, such as manuscript illumination, we almost never know the artist's name. During the Renaissance, on the other hand, the names and careers of many of the artists responsible for a sustained level of innovation and excellence in stained glass are more thoroughly documented. There were many independent painter-glaziers in Germany, for instance, who designed and executed their own windows. During the mid to late fifteenth century, Peter Hemmel von Andlau produced work for sites all over Germany from his busy shop in Strasbourg. Though his is not a familiar name today, he was one of the glaziers most sensitive to the expressive qualities of stained glass.

The Resurrection of Christ

Detail, fragment from St. Pierre le Vieux, Strasbourg, c. 1400;

h. 32¾ in. (84 cm). Musée de l'Oeuvre Notre Dame, Strasbourg, France.

The ruby red over the mantle of the revived Christ dominates the composition, while the predominantly cobalt blue of the soldier's recumbent body recedes against it; the juxtaposition perfectly expresses the powerlessness of human measures to impede divine will. Although the date of the work suggests the international Gothic style, the bold use of color and patterning exhibit a further aspect of the movement that was explored only in stained glass.

Moses on the Mountain

Designed by HANS ACKER, c. 1430–31; 65.5 x 38 cm. Besserer Chapel, Ulm Minster.

Acker was one of the most innovative artists of his time and developed a vein of pure expression in stained glass. The many intimately scaled scenes of the Besserer Chapel offer extraordinary testimony of a continuing reformulation of the medium in northern Europe as the early Renaissance began.

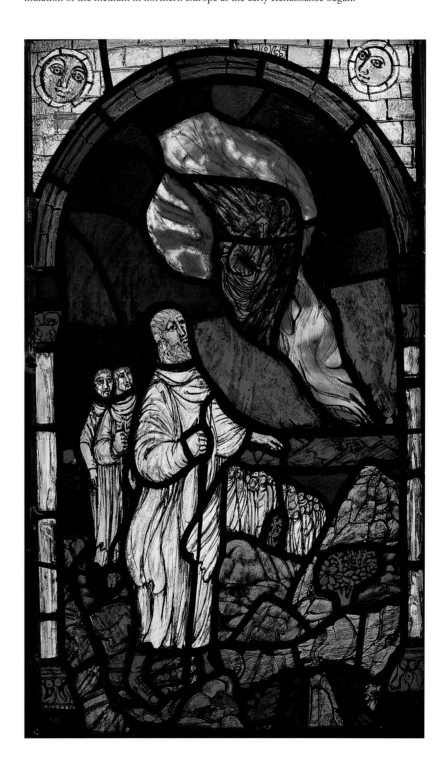

Moses on
the Mountain

Detail; designed by HANS ACKER,
c. 1430–31; 25½ x 14⅞ in.
(65.5 x 38 cm). Besserer
Chapel, Ulm Minster.
The imaginative scope
and technical innovation
of artist and executor
make for a dramatic
effect. The red of the
pillar of fire was flashed
onto yellow glass to
create a mottled image
of a twisting, "living"
flame. Details were
scratched through the
dark, still-wet enamel
modeling with the point
of the brush to produce
a wonderful array of en-
livening, spontaneously
executed highlights.

**The Agony
in the Garden**

*Oculus window in drum of dome,
Florence Cathedral; designed by
LORENZO GHIBERTI, c. 1440s;
d. 15 ft. 5 in. (4.7 m). Florence, Italy.*
Ghiberti's lucid concep-
tion of the supernatural
event reflects the uniquely
rational Florentine
conception of pictorial
art. For the first time in
stained glass, the compo-
sition is conceived of as
a fluid continuum of
naturalistic light, space,
and form. A balance is
struck between effects of
painterly illusionism and
the clarity of the image.

The effect of the varied forms of realism on fifteenth-century stained glass was even more profound than it had been in the preceding century. The art of painting had defined a new approach to representation that the other arts were to follow. The continent still consisted as much of independent cities or regions as great nation-states. Consequently, highly individual artistic styles evolved in each of these centers as they reached the height of their economic and political importance. Much of the art of the early Renaissance was popular or civic in tone, but local traditions varied widely.

In Italy, stained glass is often considered inim-ical both to the sunny climate and the rational thinking of classically minded artists. Although the art was not practiced as widely as in the north, the examples produced in Italy are among the most strikingly original and beautiful windows of the period. The stained glass designs of artists who primarily worked as sculptors and painters often achieved levels of brilliance comparable to those who specialized in stained glass. The Ital-ian sculptors Ghiberti and Donatello and the painters Uccello and Andrea del Castagno con-tributed stunning designs for the production of the *tondi*, or circular windows, that ring the drum of the majestic dome in Florence Cathedral. These works of the 1440s present a comprehen-sive survey of the most advanced pictorial princi-ples found in the early Italian Renaissance. The full-scale designs—or cartoons—certainly are to be credited to these painters and sculptors, but the color contrasts and accents may have been designed in consultation with the master-glaziers who produced the windows.

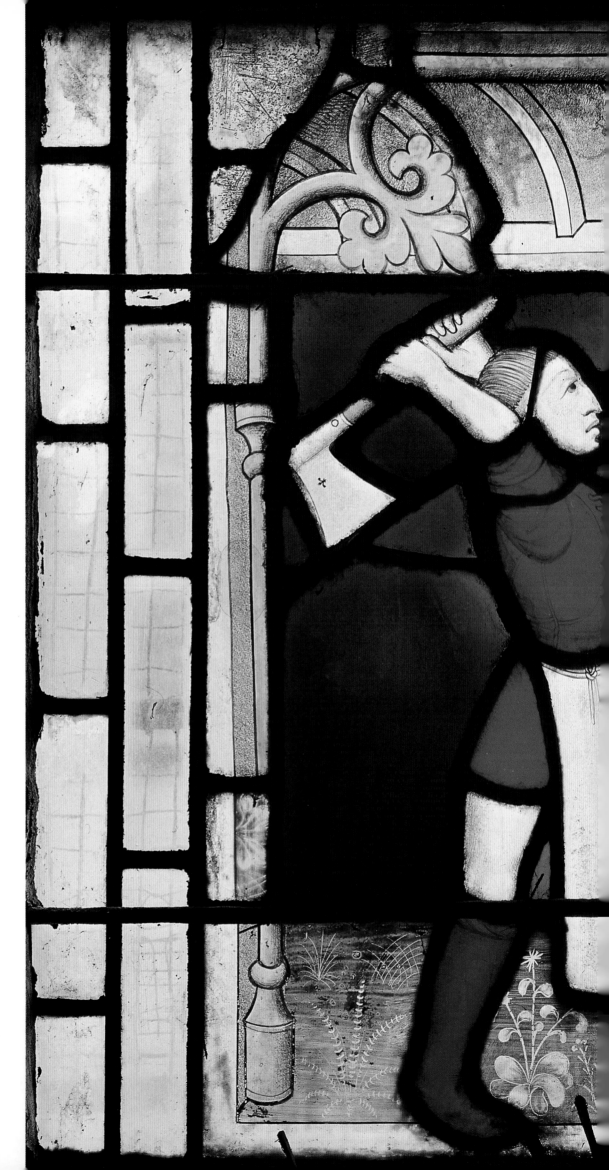

Slaughtering
a Bull

*Detail from the window of
the Butchers, Church of Notre-
Dame; c.1460–1470. Semur-
en-Auxois, Burgundy, France.*
The frozen action of
the butcher, his unfo-
cused stare, and the
prominent, enclosing
lead lines impart a
starkly geometric
quality to the image.
Such broad, bold pat-
terning of scarcely
modulated color and
shape was one of the
main strengths of the
northern European
Renaissance artist
and is especially
striking when applied
to the quasi-heraldic
concerns of the donor.

Madonna and Child

From diptych of Martin van Nieuwenhowe; HANS MEMLING, 1487; oil on panel, 17½ x 13 in. (44.7 x 33.5 cm). Hospital of St. John, Bruges, Belgium.

This altarpiece panel attests to the presence of silver stained roundels in upper-middle-class Flemish homes. The imagery concerns the social status of the family, as indicated by the coat of arms and four roundels depicting the hand of God scattering coins over fruitful ground.

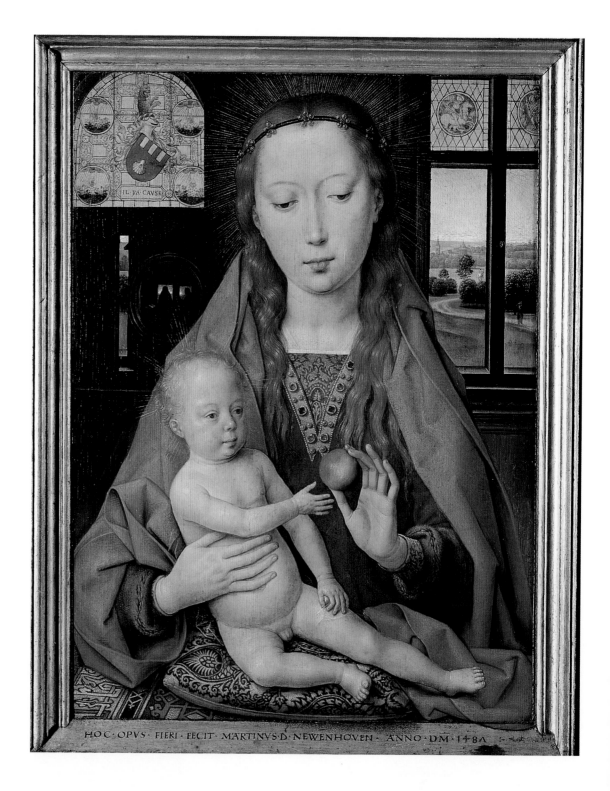

HOC · OPVS · FIERI · FECIT · MARTINVS · D · NEWENHOVEN · ANNO · DM · 1487

Sorghbeloos and Lichte Fortune

c. 1520; silver-stained glass roundel; d. 10⁵/₈ in. (26.99 cm). Toledo Museum of Art, Toledo, Ohio. Featuring a morality play popular in the lowlands of sixteenth century Europe, this roundel tells the story of youth gone astray. Executed entirely in silver stain, using fine brushes, it achieves the same intimacy of subject and luminosity found in contemporary Flemish panel painting.

Among the most fascinating innovations of the early Renaissance period is the silver stain roundel. Rarely more than twelve inches (thirty centimeters) in diameter, these works originated in England and quickly formed a permanent part of the glazier's art in the lowlands. Roundels were primarily destined for domestic settings, although some were placed in civic buildings and churches. The imagery of these diminutive works almost always alludes to moralistic or religious themes, but their expression is often so vernacular in flavor that they can legitimately be considered a form of secular glass. In the roundels of the lowlands, devotional imagery and heraldic devices appear together in the manner of familial statements of faith. Content was treated with a wealth of detail directly associated with contemporary Flemish panel paintings and manuscript illuminations. Over time, the vicissitudes of taste and ephemeral nature of the domestic settings have displaced almost all silver stain roundels from their original contexts, but contemporary panel paintings faithfully recorded the effect of these works in middle-class interiors.

Sorghbeloos and Lichte Fortune

Detail; c. 1520; silver-stained glass roundel; d. 10⅝ in. (26.99 cm). Toledo Museum of Art, Toledo, Ohio.

The art of the lowlands favored a satirical, moralizing approach to life. A youth, Sorghbeloos (Careless), has strayed from the straight and narrow and allowed fate (Lichte Fortune) to lead him down a ruinous path.

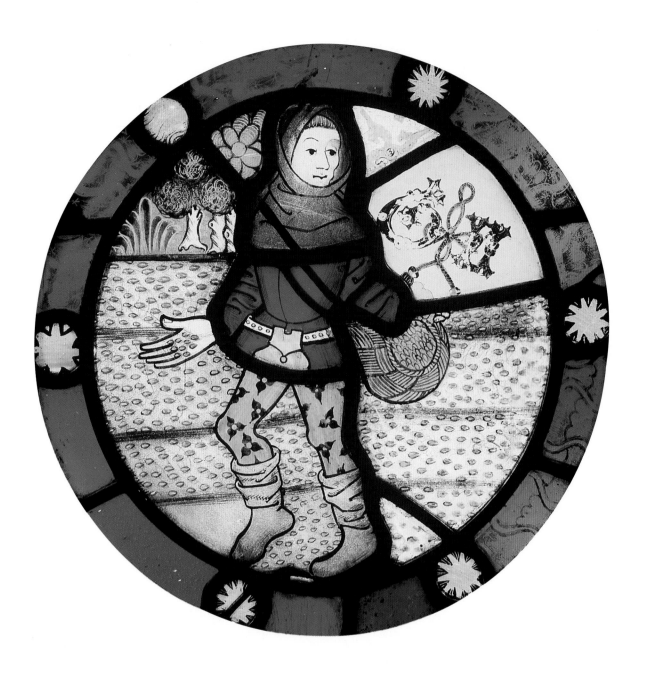

The Month of October: Sowing

Norwich School, c. 1480–1500; colored glass and silver stained roundel;

d. 8 ft. (2.44 m). Victoria and Albert Museum, London, England.

This charming rustic image stands midway between naturalism and symbol.

The roundel formed part of a series of typical activities, each of which was

interpreted as part of the divinely established, eternal rhythm of the cosmos.

Such intimately scaled works were commonly installed in a domestic or civil setting

and were intended to provide a form of moral instruction as well as viewing pleasure.

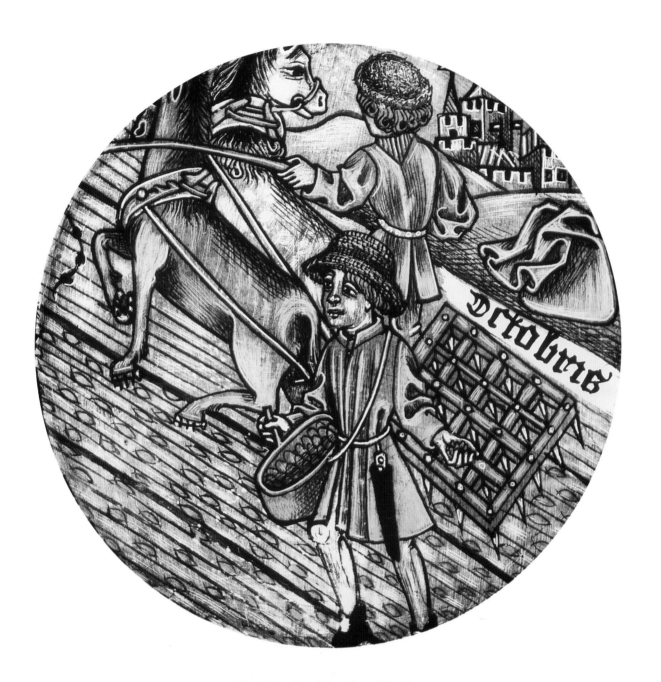

The Month of October: Plowing

Norwich School, c. 1480–1500; silver stained roundel.

Victoria and Albert Museum, London, England.

The act of sowing is here accompanied by
the preparation of the soil by plowing.
The scene has a great appeal as genre and
points to future developments in landscape
representation in stained glass and other media.

Antiochus Punishing the Maccabees

Designed by DIERICK VELLERT, c. 1520–1535; stained glass, 27¼ x 18½ (70.48 x 46.99 cm).

Mr. and Mrs. Isaac D. Fletcher Collection, Metropolitan Museum of Art, New York.

This composition, complex and full of movement, manifests the quick absorption of Italian High Renaissance and mannerist art by Flemish artists. The exaggerated elegance of pose, rhetorical gestures, and a deliberate compression of scale are enhanced by the northern propensity for detail and naturalistic tonal effects. The steeply rising composition respects the two-dimensional plane of the glass panel.

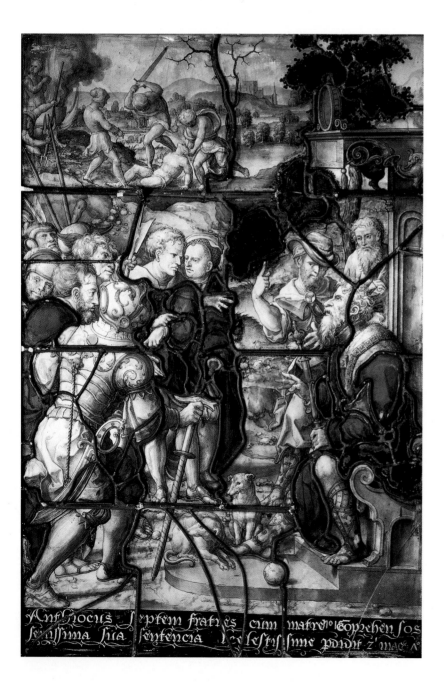

THE HIGH RENAISSANCE: EUROPE UNIFIED BY ART: 1500–1550

The first half of the sixteenth century witnessed the final flowering of stained glass before the modern period. The extent of human ingenuity and ambition was clearly proved by the discovery of America by Columbus and the remarkable empiricism of Leonardo da Vinci. An unprecedented amount of stained glass, almost all of high quality, was produced in this brief period. The artists of the sixteenth century shared, for a generation or two, a nearly universal formal and technical language. The heroic scale of Italian High Renaissance art, as magnificently set forth by Raphael, da Vinci, and Michelangelo, forever changed the conception of the visual arts in Europe. In it, the unity of the human and the divine spirits was ideally stated. The expression of this sublime relationship was accomplished through a profound recasting of the principles of classical art for the embodiment of humanist aspirations.

Like the other pictorial arts of the High Renaissance, stained glass was transformed by ideas exported from Italy. Gifted artists such as Albrecht Dürer absorbed the lessons from Italy and infused them with a uniquely northern spirit still marked by its late Gothic heritage. Rather ironically, there is little High Renaissance stained glass in Italy itself, and where it is found, it was usually produced by artists from northern Europe. The fully developed classicism of the High Renaissance inspired a

The Creation of Eve

Detail from Twelve Scenes of the Creation; *1526. Donated by Pierre de Provins, future mayor of Troyes. Troyes, Saint-Florentin (transparency label says St. Madeleine).*

One of a series of horizontally arranged scenes from the creation, Eve is blessed by God as she emerges from the rib of Adam. God is dressed as a pope, a guise that must have been intended to indicate the power of the papacy to absolve sin. The series is a superb example of the combined effects of silver stain, stippled modeling, and colored glass to produce an illusionistic image in both color and tone.

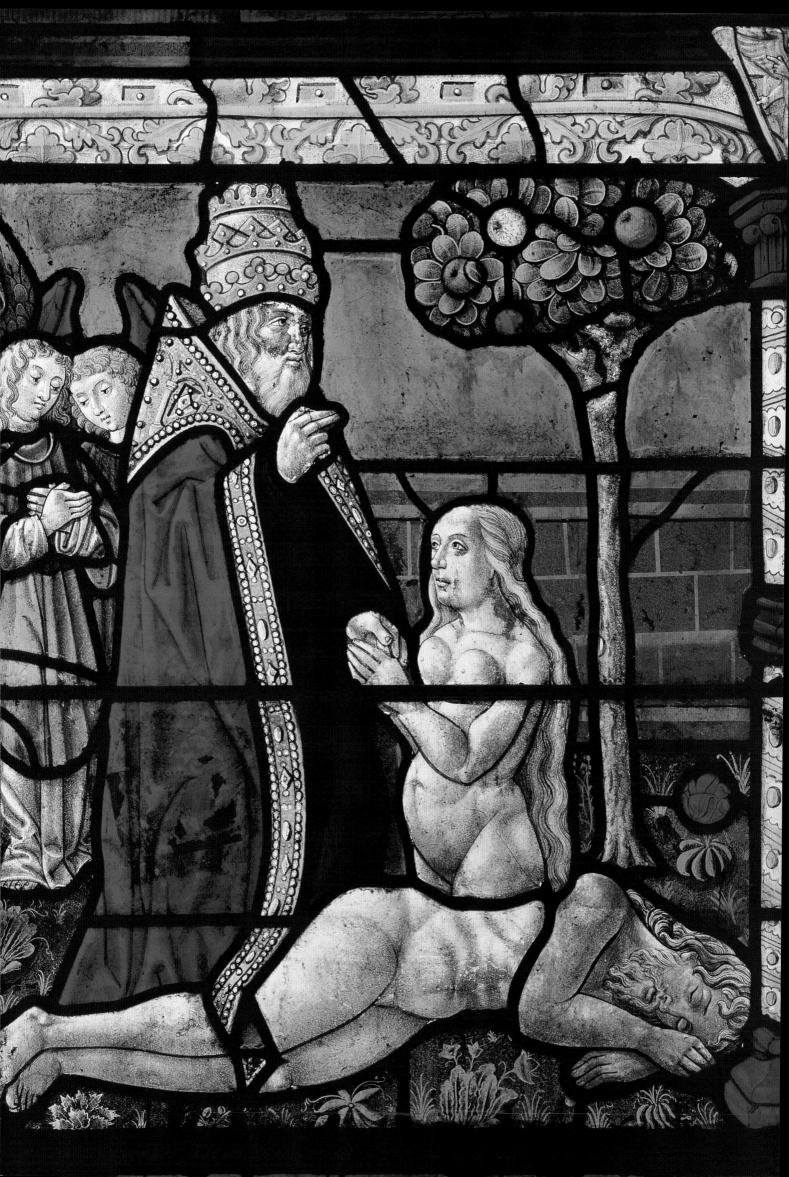

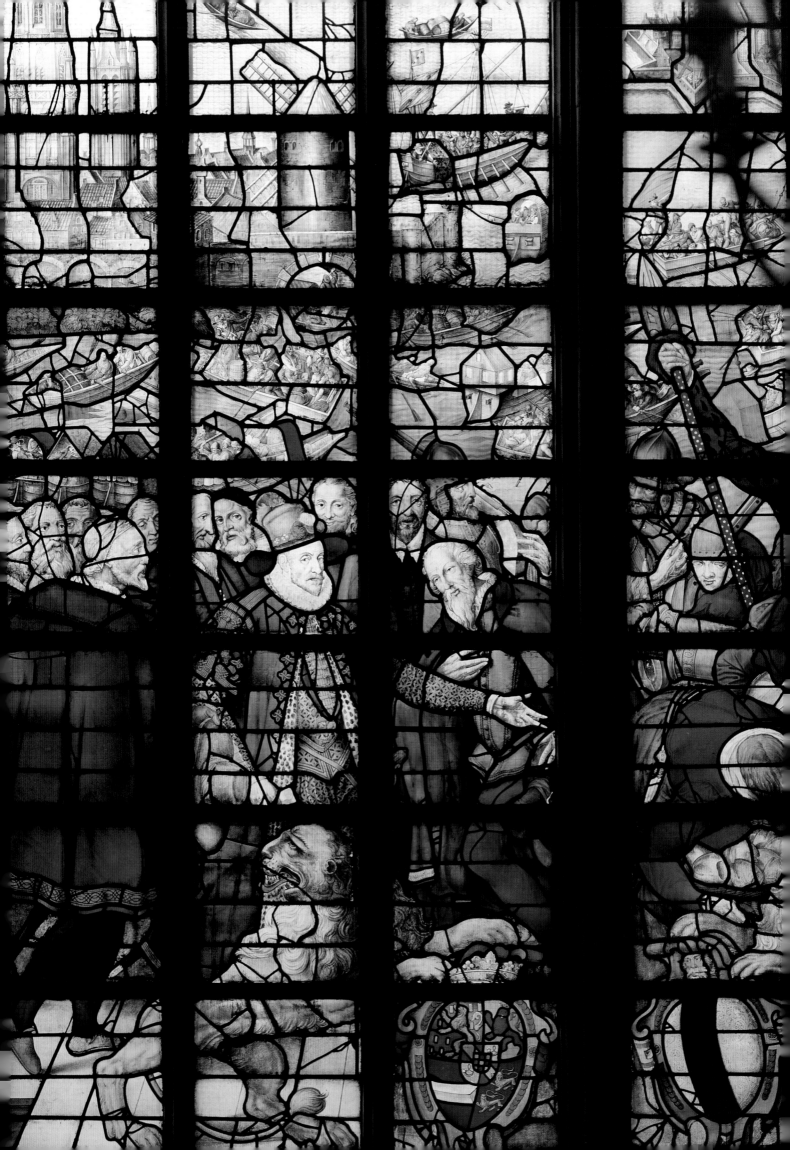

dramatic new use of stained glass in the north. The rational proportions and monumental scale of the High Renaissance were wedded to the realism, attachment to courtly service, and decorative nature of northern European art. The result was an imagery of great majesty, ceremonial pomp, and descriptive power.

The stylistic renewal of stained glass in the High Renaissance was also accomplished by means of important technical advances. Among the latter were the increased size, clarity, and fineness of colored and clear glass and the introduction of a ruddy hematite stain that could be employed in the same manner as the already existing silver stain. Examples of the increased use of silver stain on large areas of brilliantly colored glass are found in the works of Engrand le Prince of Beauvais. In the early sixteenth century, he and his brothers greatly influenced the art of their region with distinctive stained glass work. Engrand often developed entire compositions around the gilded effect produced by silver stain, as in his spectacular *Jesse Tree* window in St. Etienne at Beauvais. The shimmering brilliance of this stain harmonizes with the bold, saturated blue and red glass surrounding it.

The technical and aesthetic developments of the early sixteenth century encouraged the reduction and regularization of the leading in the design and execution of windows. The goal was a sweeping effect that would only have been impeded by the presence of heavy, undulating leading. A greater consistency of visual effect could be produced by staining, abrading, and

King Philip II of Spain Visiting a Dutch Port

Sixteenth century. St. Janskerk, Gouda, Netherlands.

The use of perspective and the realistic rendering of the background landscape combine with the large group portrait effect to reflect a typically Dutch style of scene painting. While the foreground is dominated by the pomp of the King's arrival, the middleground and background offer a charming view of a working Dutch port, with windmills looming over fishingboat-filled waters.

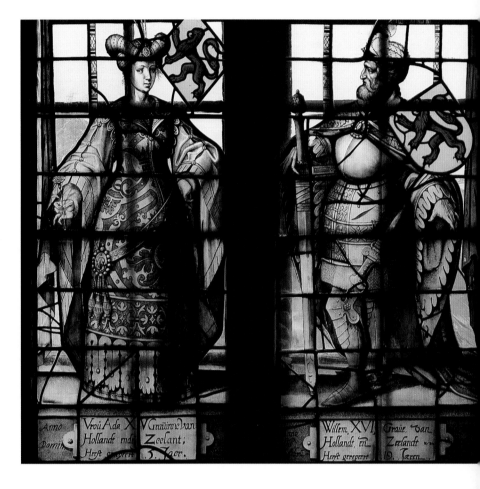

drawing in opaque enamel on single panels of glass. Traditionally colored glass, as opposed to that made using stain, still formed an essential part of the glazier's working method. Stained glass making in the early sixteenth century was characterized by an unprecedented range of techniques and materials used to realize some extremely complex visual effects. Not surprisingly, the work of this period emphasizes harmonious design and coloristic effects over distortion of form or emotional expression.

In Holland and Flanders, a potent blend of native realism and Italian breadth of form produced a stained glass style of majestic proportions. The outsized scale of the most memorable windows was encouraged by the presence of the Holy Roman Empire's court at Brussels. The Flemish painter Bernard van Orley designed the first of two huge windows

Count Willem of Holland and Zeeland and his Wife, the Countess Ada

Artist unknown, 1588. St. John's Church, Gouda, Netherlands. Made later than the lancet windows of the Crabeth brothers, these figures make up part of a series of the counts of Holland. They are exceptional examples of *grisaille*, or monochrome staining on clear glass. The armorial shields introduce the only notes of bright color.

facing each other across the transept of Brussels Cathedral. Set in place in 1537, the window's composition is established by an elaborate triumphal arch, beneath which stands the commanding figure of Emperor Charles V. The refined technique of abraded layered glass, the suppressed richness of coloring, and the celestially suggestive blue background, represent the height of accomplishment reached by the glazier's art during the sixteenth century.

In the Netherlands, an equally grand but less decorative style was evolved by the Crabeth brothers, Dirck and Wouter. These highly talented glaziers were inspired by mature examples of Italian High Renaissance art. The pair designed and executed several windows for their hometown church of St. John at Gouda. For this commission, Dirck Crabeth executed *The Expulsion of Heliodorus from the Temple*, the composition of which vigorously conflates the setting and narrative structure of two frescoes by Raphael in the Vatican Palace. This highly original work displays a full embrace and understanding of Italian High Renaissance art by a northern artist.

The elaborate compositions of many large Dutch and Flemish windows span all interior divisions of the window in their quest for pictorial breadth and illusionism. In the work of van Orley and Dirck Crabeth, this impulse is suppressed by the limited extension into background depth. Work of this degree of excellence continued well into the second half of the sixteenth century in the Netherlands and elsewhere. Flemish artists and glaziers dominated stained glass making throughout Europe at this time, working first in England, then in Spain and Milan. The windows for Milan Cathedral, for example, were being produced almost to the end of the sixteenth century.

THE ECLIPSE OF A TRADITION: 1600–1800

The highly accomplished work of Dirck Crabeth in Gouda and his contemporaries continued undiminished through most of the sixteenth century. Within a generation, however, the great beauty and sophisticated technical standards of stained glass had greatly declined throughout Europe. By the mid-seventeenth century, hardly any large-scale glass of any real consequence was being produced. The reasons for this turn of events is found in the disruptive effects of the Protestant Reformation and its equally determined opposition by the Catholic Church. Political motives were also involved, and the resulting turmoil convulsed Europe.

With these events in mind, it is not difficult to imagine a detrimental effect on the arts. In the case of stained glass, however, such adverse circumstances led to the end of the medium as an innovative art until its revival in the mid-nineteenth century. Painting in Catholic countries during the second half of the sixteenth century became increasingly conservative and in support of the official church position. Stained glass, always allied to the arts of its time, could only follow the same course. In addition, the adoption of opaque, enamel pigments greatly inhibited the light-infused quality of colored windows. A further blow to stained glass as a medium came with the destruction of the major glass-producing centers in Germany during the Thirty Years' War (1618–1648).

With both materials and techniques debased, the art of stained glass was left in a confused state. Meanwhile, the reinvigoration of painting, sculpture, and architecture in the baroque period held no place for the use of colored light. Before the Counter Reformation, stained glass

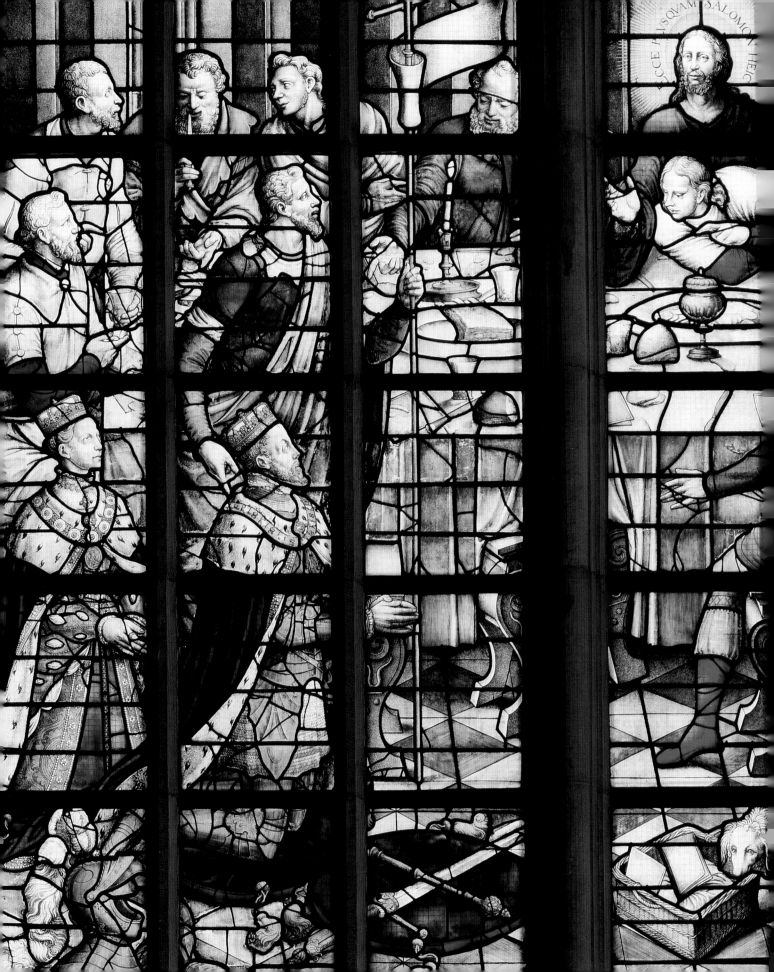

Allegory of Christ as Savior, with the Fall of the Manna Above

Detail; artist unknown, 1612–1622. St. Etienne du Mont, Paris, France.

Though traditional techniques such as silver stain and colored glass were used, especially for the bright red ruby pieces, many areas of clear glass are stained or enameled with a range of colors like green and blue. Especially notable is the blended color within the clothing of two background figures.

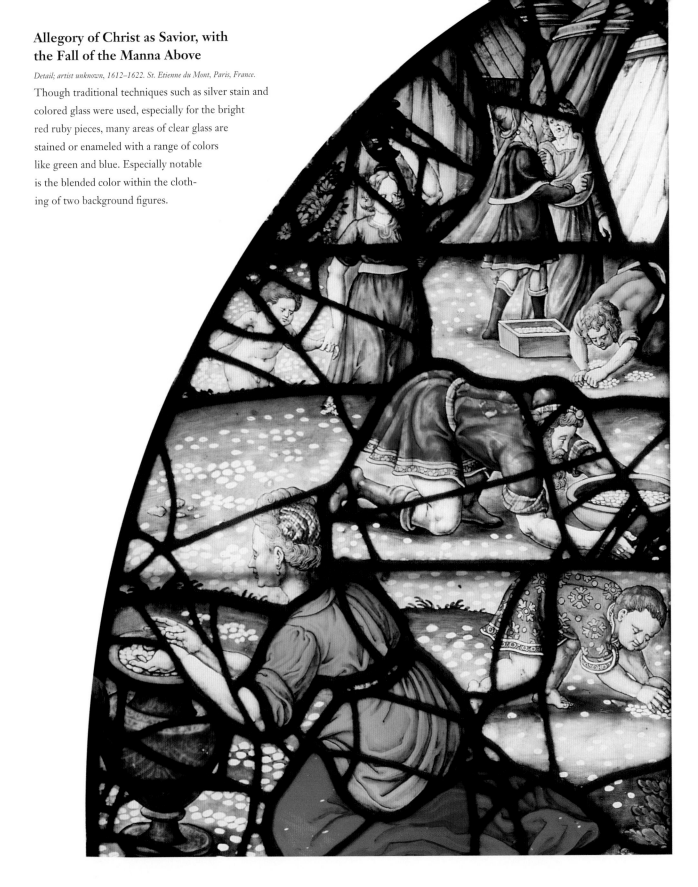

FOLLOWING PAGE:

The Last Supper

Detail; DIRCK CRABETH,
c. 1555–1570. St. John's
Church, Gouda, Netherlands.
The faces in the
window, especially
those of the portraits,
are painted with
extreme refinement
and reflect the con-
temporary style
of portrait painting
in the Netherlands.

**Count Willem
of Holland and
Zeeland and
his Wife, the
Countess Ada**

Detail; artist unknown,
1588. St. John's Church,
Gouda, Netherlands.
The intimate details of
this royal double portrait
contrast with the stark
use of color in the glass,
producing a familiar,
yet reverent image.

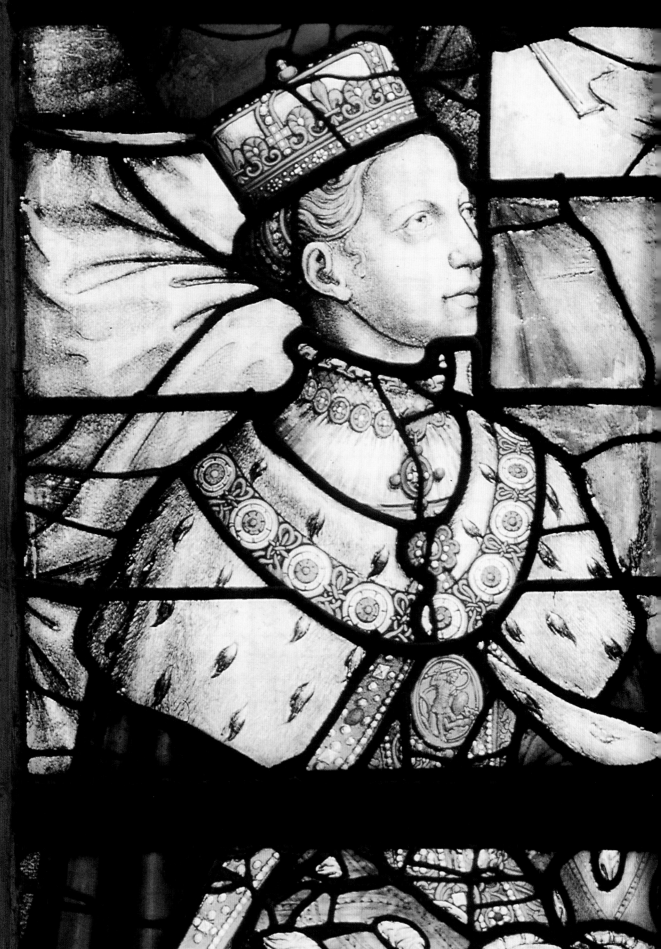

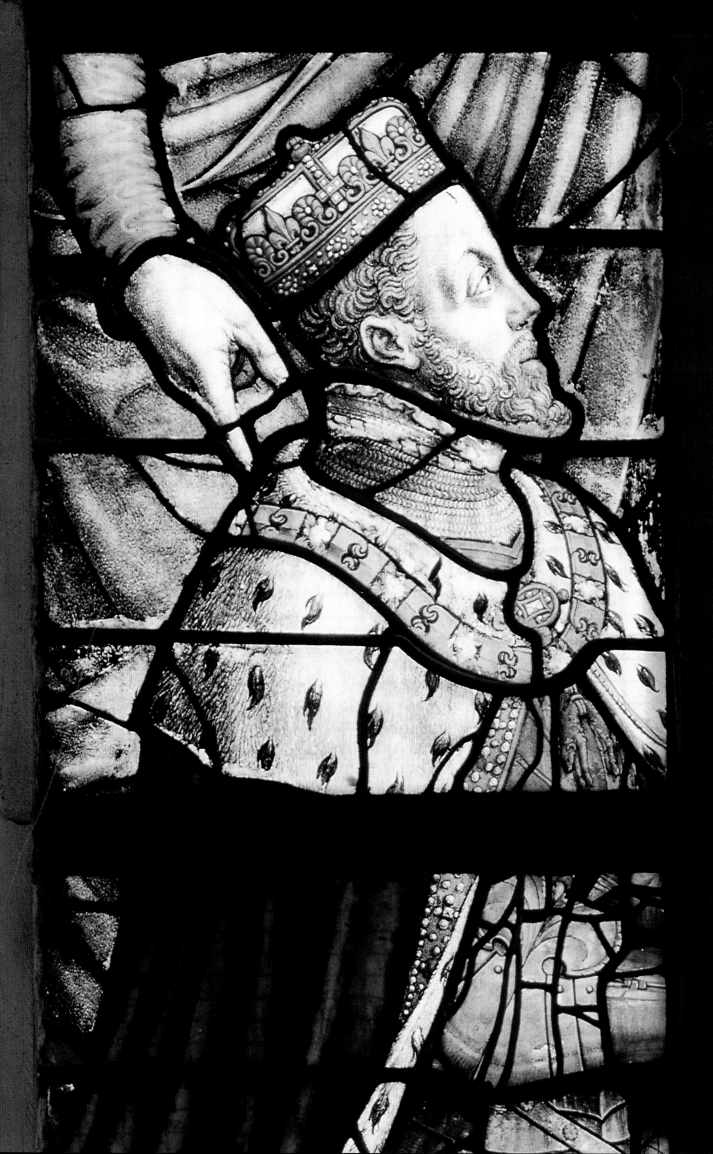

**Allegory of
Christ as Savior,
with the Fall of
the Manna Above**

Artist unknown, 1612–1622.

St. Etienne du Mont, Paris, France.

In the lunette above, the
miraculous fall of manna
from heaven saves Moses
and the people of Israel
from famine; below,
Christ is symbolically
manifested to the world
in a similar role as savior.
Beyond the degree of
painterly effects seen
in this early baroque
window, stained glass
cannot truly retain its
full degree of saturation.

had ideally expressed the confident unity of the Catholic faith. With the urgent situation of a religiously divided Europe, however, the church needed more concrete artistic forms to fully impose its authority.

Only an institutional crisis of this great magnitude could eclipse the role of stained glass. The circumstances of its end bring to mind the equally momentous events surrounding its beginning. The great age of religious stained glass began with the sweeping reforms of the church that occurred in the late eleventh and early twelfth centuries. It ended in another period of profound redefinition, this time, though, one that was motivated by a much more conservative reaction to divisive forces within the dominion of the church.

During the seventeenth and eighteenth centuries, a delightful twilight of stained glass appeared. In England, the lowlands, and Switzerland, small-scale panels of heraldic and religious subjects continued to be produced by the thousands, primarily for use in the home. These works transcended the polemical issues of their time to serve a peripheral role as decorative objets d'art or providers of moral lessons. Almost all were painted in silver stain or colored enamels on clear glass. The light-obscuring effect of opaque color, so detrimental on a large scale, often produced a vividness of hue and design that was ideally suited to the smaller role imposed on stained glass by the religious climate of the period.

EIGHTEENTH-CENTURY STAINED GLASS

Stained glass held little interest for those living in the eighteenth-century spirit of Enlightenment. For the natural, or moral, philosopher, the religious content of stained glass seemed antithetical to the humanist affirmation of the rights of man in the newly defiant secular world.

Where intellectual ferment was converted to political reality, stained glass was even more aggressively repudiated. Much medieval glass was destroyed in the French Revolution due to the reaction against the centuries-old alliance between the Catholic Church and the royal court. Particularly lamentable was the partial destruction and dismemberment of Abbot Suger's epochal windows in the apse of St. Denis.

During the same period in England, where political change was less traumatic, eighteenth-century pictorial glazing underwent a modest phase of development in the Georgian era. Painted in opaque enamels on large, regular panes of transparent glass, stained glass was totally absorbed by the illusionistic principles of oil painting.

In one sense, however, the long tradition of stained glass retained a degree of its former integrity. Painted glass was designed by such prominent artists as Sir Joshua Reynolds and was used to depict high-minded themes in large-scale settings like college chapels and other ecclesiastical interiors. Stained glass as a concept therefore remained in the artistic consciousness of the time, and only a changed attitude toward its technical aspects was required to restore a sense of authenticity to the medium.

By the late eighteenth century, connoisseurs were beginning to appreciate the beauty of historic stained glass. Attempts were made to rediscover the "secret art" of colored and painted glass, but with only partial success. The quest for a revitalized appearance of stained glass was only satisfied, paradoxically, in the mid-nineteenth century, when the relentless drive of the Industrial Revolution sparked a yearning for a greater sincerity in the arts.

CHAPTER THREE

REVIVAL IN THE AGE OF PROGRESS

MOVING BACKWARDS AND AHEAD

The late eighteenth and early nineteenth centuries ushered in an age of political upheaval and technological change that revolutionized the lives of western Europeans. Industry and transportation were transformed within one or two generations at a rate and degree greater than that experienced during any previous period in history. Life in nineteenth-century western Europe, and especially in England and France, was driven by new forces. In England, where the effects of industrialization were especially marked, many took alarm at their country's new social plight. In a search for social and artistic ideals felt to be sorely lacking, a Gothic revival began to dominate architecture and design by the middle of the century.

The revival of all things medieval was led by, among others, A.W. Pugin, best known for his decorative work in the new Houses of Parliament. Through their writings, art and designs, Pugin, John Ruskin, William Morris, and others extolled an honesty of expression that they felt permeated the thirteenth-century Gothic style. Simultaneous with the appearance of ideas about medieval culture were attempts to restore original examples of medieval glass. Gothic medallion windows in Canterbury Cathedral were restored after centuries of neglect. The examples of medieval glass that had escaped the destruction wrought by religious and political upheavals was often in fragmentary, ill-repaired condition. Responsible for the good-intentioned, but sometimes unsuccessful, "restoration" of scores of medieval stained glass windows was Eugène Emmanuel Viollet-le-Duc, a French architect, antiquarian, and appointed head of the *Monuments Historiques*. Among his works is a large and influential treatise on medieval art containing a lengthy section on stained glass.

Epic tales and Gothic legends about knights and courtly love were objects of fascination and imitation by the promulgators of the Gothic revival—architects, painters, designers, and writers. Of equal interest were the handicraft techniques that had been vital to medieval culture, such as illumination and bookmaking, carpet and tapestry weaving, cabinet making, metal smithing, and, of course, stained glass making. Dominated by this kind of historicism, the nineteenth century saw a self-conscious revival of the decorative arts and an emphasis on surface decoration. These developments set the stage for subsequent design shifts throughout the rest of the century and beyond: notably, the Arts and Crafts movement and Art Nouveau.

Committed to design reform, the Arts and Crafts movement was founded in England in the idealistic spirit of William Morris (1834–1896). The aim was to improve conditions for the working classes. For vast numbers of artisans, the movement's schools and societies provided access to technical training in a variety of mediums—stained glass among them. The popular dissemination of crafts as hobbies

Roses and Moutettes

Detail; JACQUES GRUBER, 1904.
Glass panel for the Weissen
Home, Nancy, France.

The late nineteenth and early twentieth centuries saw a revival of the decorative arts, including stained glass. The elegant style of Art Nouveau—characterized by ornamental, sinuous lines—flourished from the 1880s to the beginning of World War I.

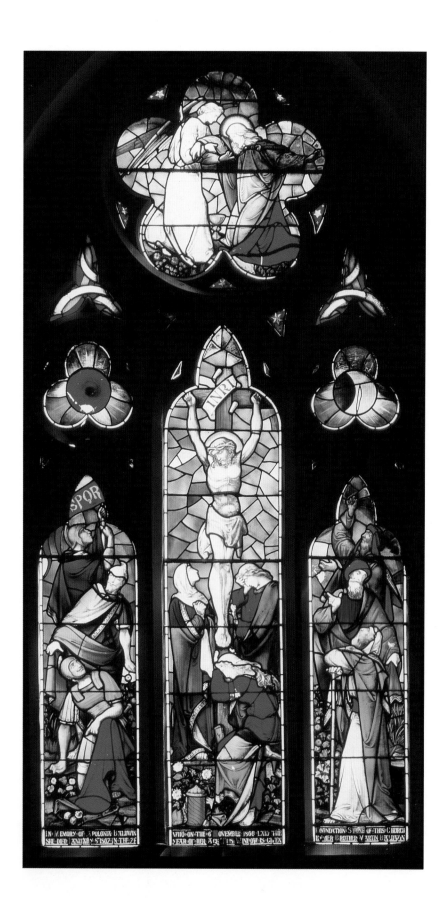

for people of all classes and skill levels contributed greatly to the rise of the amateur artist. In contrast, Art Nouveau artists centered on the exotic world of the imagination and the mystical designs of nature. Refined and exclusive, the style was disseminated widely through international expositions, journals, and travel.

Initially, stained glass was revived in tandem with other medieval or Gothic handicrafts. Beyond the initial impetus of the neo-Gothic style, however, stained glass assumed an important decorative role for artists and designers throughout the century. A monied class had arisen with the means to furnish their homes and memorialize loved ones with stained glass. The market was extremely encouraging for stained glass and other decorations from full-service design firms such as Morris & Co. in London, L'Art Nouveau Bing in Paris, and Tiffany Studios in New York. However the medium was revived, or its techniques revitalized or reinvented, by the end of the century, stained glass was fully integrated into both public and private architecture and decoration.

The Crucifixion

WILLIAM GARDNER, nineteenth century.

Bradley Church, Staffordshire, England.

The nineteenth-century revival of stained glass began with the restoration of Gothic cathedrals, part of an overall trend that dominated architecture and design through the turn of the century.

The Crucifixion

THOMAS WILMSHURST, nineteenth century.

Leigh Delamere Church, Wiltshire, England.

As in the Gothic era, biblical scenes proliferated Gothic-revival stained glass. However, scenes from epic tales of classic literature would soon proliferate, as stained glass moved from the religious realm of churches and cathedrals to the secular world of public buildings and private homes.

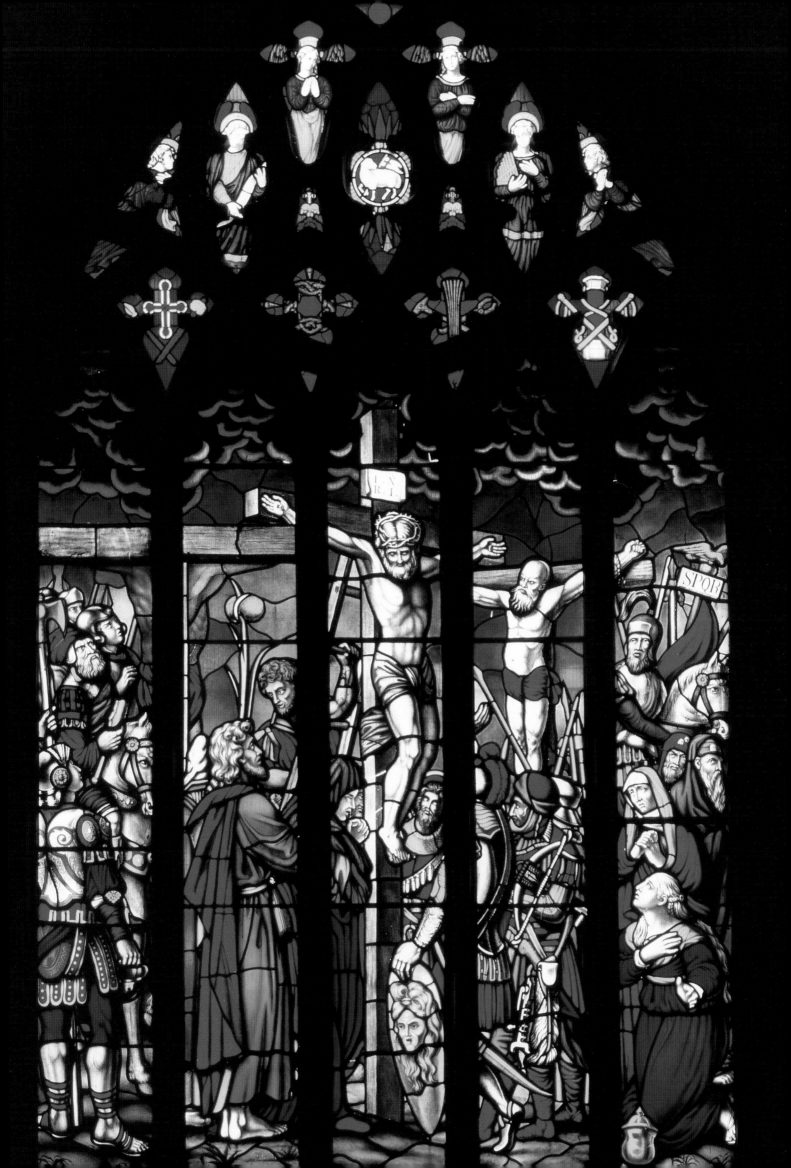

WILLIAM MORRIS AND STAINED GLASS

One of the most influential designers of the nineteenth century was William Morris. Born to an affluent family, Morris had a substantial independent income throughout his life that allowed him to support his many ventures in the decorative arts. Through his commercial firms—Morris, Marshall, Faulkner & Co., the Kelmscott Press, and Morris & Co.—he exercised his prodigious skills as art director, business manager, merchant, and marketer. A man of unmatched energies and talents, Morris was a superb flat-pattern designer and colorist, a knowledgeable art historian, a passionate conservationist, and a political activist.

At Oxford, Morris met Edward Burne-Jones (1833–1898), who would remain a close and faithful friend throughout Morris' life. Morris and Burne-Jones traveled to the seats of Gothic culture and were so struck by their encounters with medieval architecture, sculpture, and stained glass that they abandoned their plans to become monks and devote themselves to art. The friends took up residence in London, and Burne-Jones applied himself seriously to

Beardless King

Designed by EDWARD BURNE-JONES, executed by William Morris, c. 1860. Victoria and Albert Museum, London, England.
Burne-Jones produced hundreds of stained glass windows, many in collaboration with longtime friend William Morris. Morris developed an original yellow dye that was remarkably flexible in covering a wide tonal range.

Architecture

Detail; From King Rene's Honeymoon series; designed by EDWARD BURNE-JONES, executed by Morris, Marshall, Faulkner & Co., 1863. Victoria and Albert Museum, London, England.
The stained glass and other ecclesiastical work produced by Morris & Co. re-introduced medieval values without resorting to mimicry.

painting while Morris became for a short time a pupil in the neo-Gothic architectural firm of George Street. There, Morris made the association of Philip Webb, another of the designer's lifelong friends and collaborators. Webb designed a home, the "Red House," for Morris and his new bride, Jane Burden.

Unable to find just the right furnishings for his new home, Morris and friends made decorative articles for it. Encouraged by this collaboration, the friends formed Morris, Marshall, Faulkner & Co. in April 1861. Based on Morris's ideal of a medieval workshop, the firm eventually produced wall paintings and embroidery, furniture, tableware, stained glass, and ceramic tiles. In 1862, the firm first showed its wares at the International Exhibition in London, and its display of stained glass won a medal,

Sculpture

From King Rene's Honeymoon series; designed by EDWARD BURNE-JONES, executed by Morris, Marshall, Faulkner & Co., 1863. Victoria and Albert Museum, London, England. The variety of home furnishings produced by Morris & Co. reflected the Pre-Raphaelite brotherhood's fascination with classical themes as well as the firm's commitment to the decorative arts.

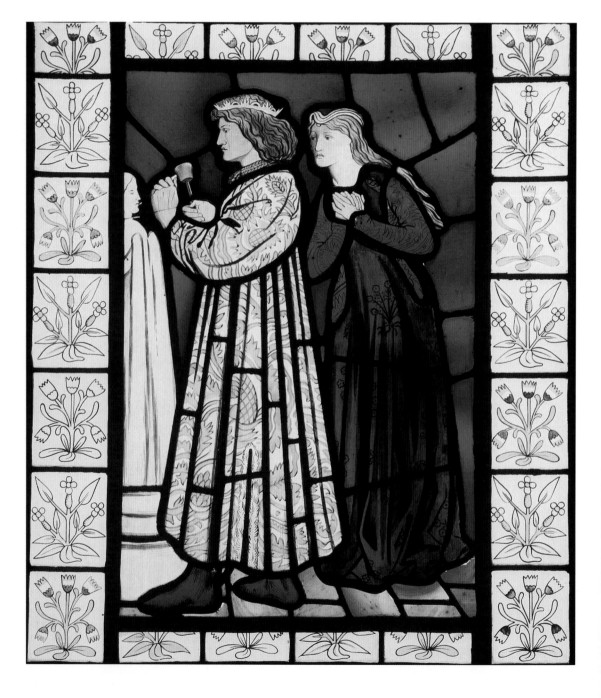

with a special award given to Burne-Jones for his designs.

Burne-Jones had been making stained glass designs since 1857, when he was recommended to James Powell & Sons as a designer by Dante Gabriel Rossetti (1828–1882). As was clear from an 1858 exhibition of his stained glass designs at the Hogarth Club—a gathering place for like-minded medievalists—the artist's style meshed well with the demands of the medium. Burne-Jones's cartoon, "The Good Shepherd," was noticed by John Ruskin, who reportedly was "driven wild with joy." Between 1857 and 1861, Burne-Jones designed five sets of windows for James Powell & Sons. As Burne-Jones's roommate and informal collaborator, Morris may have helped with some of these designs, as it was documented that before his

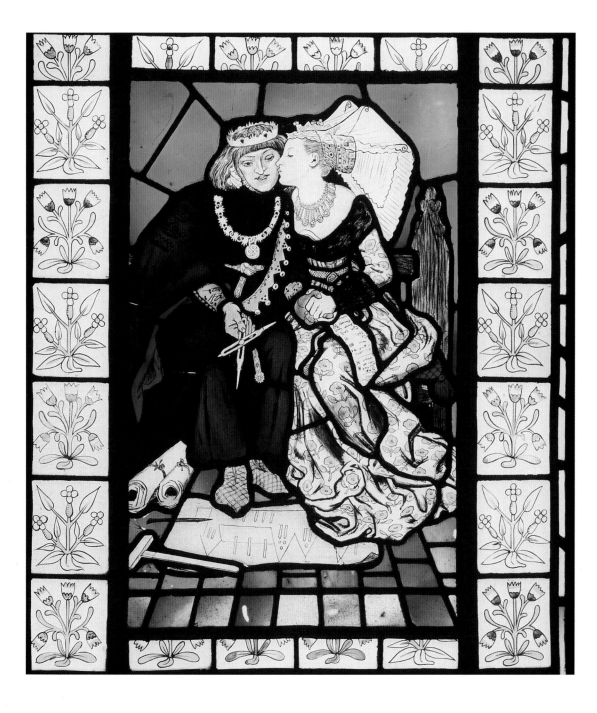

Architecture

From King Rene's Honeymoon series; designed by EDWARD BURNE-JONES, *executed by Morris, Marshall, Faulkner & Co., 1863. Victoria and Albert Museum, London, England.* Originally designed as painted panels for a wooden cabinet, these were made for the house of the painter Myles Birket Foster. Morris and his circle often recycled designs for different mediums. Fictional incidents in the life of the fifteenth century king allude to his fame as a patron and practitioner of the arts.

The Call of St. Peter

Designed by EDWARD BURNE-JONES, executed by James Powell & Sons; c. 1860. Victoria and Albert Museum, London, England.
This example of Burne-Jones's early experiments in stained glass remained, along with its cartoon, in the factory where it was made—White-friars Glass Co.—for 100 years. It shows the artist's attempts to replicate Gothic composition by "stacking" elements.

marriage he spent his time "drawing and coloring windows."

Throughout their long friendship, Burne-Jones and Morris worked well together. For the firm's stained glass production, their collaboration fell into divisions that suited each artist's strengths. For his stained glass cartoons, Burne-Jones developed a compositional approach that minimized spatial recession in favor of "stacked" elements that more closely replicated the style of Gothic stained glass. He was primarily responsible for the figural aspects of the design, while Morris would often supply the decorative motifs, or "quarries," that formed the backgrounds and borders.

Burne-Jones and other designers at Morris, Marshall, Faulkner & Co. would submit cartoons for the workshop technicians to "glassify" after Morris had overlaid the leadlines and designated color. Morris was a supreme colorist who closely grasped the beauty in the simple colors of medieval glass. His sense of color has often been credited with providing a positive example for his contemporaries to follow.

While Morris was clearly versed in the designs and motifs found in early stained glass, he was not prone to copying directly from medieval sources. Rather, he created decorative patterns that found their origins in the thirteenth century but were wholly his. Stained glass was a medium that had fascinated Morris since his undergraduate trips to northern France. The powerful visual effect of the colored light touched his imagination—it appeared in several of his early stories, and he was attracted to its narrative function.

Morris, Marshall, Faulkner & Co. dissolved after a falling-out among several of the partners, and Morris & Co. was then formed. The new firm continued to manufacture a range of goods, but the quantity of stained glass production began to decline. Morris's involvement in the conservation and preservation of old buildings persuaded him to cease producing windows for Gothic churches and design them only for newly built structures. More and more often the high bidder on stained glass projects—and with

Elaine

Designed by EDWARD BURNE-JONES, *executed by Morris & Co.,*
1870. Victoria and Albert Museum, London, England.
This figure, Elaine, wife of Lancelot and mother of Galahad, is typical of Burne-Jones's style. The firm kept an inventory of quarry patterns, which were often designed by Morris, and reworked designs to meet demand for their services.

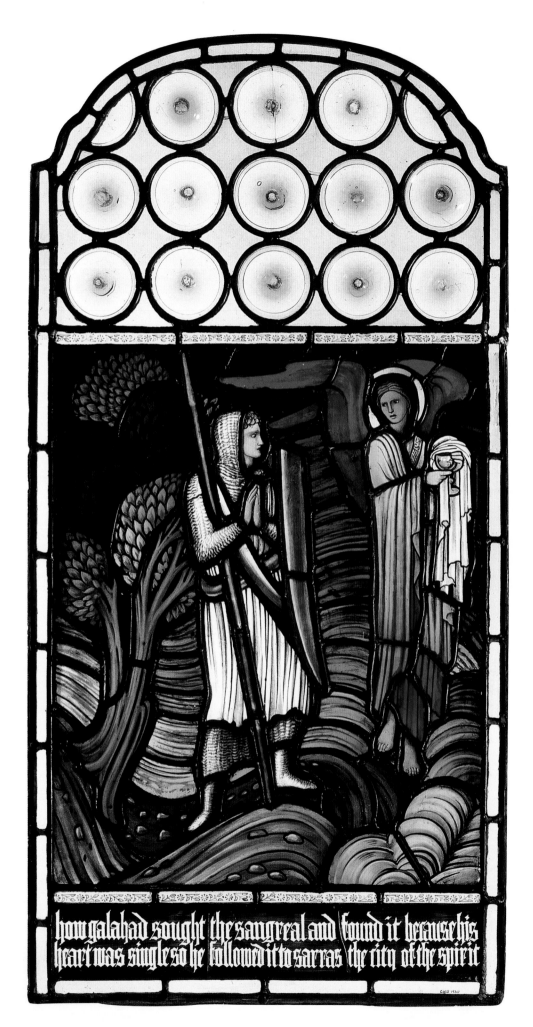

**How Galahad
Sought the Sang
Real and Found it
Because His Heart
was Simple so He
Followed it to Sarras
the City of the Spirit**

*Designed by EDWARD BURNE-JONES,
executed by Morris & Co., 1866. Victoria
and Albert Museum, London, England.*
These stylized windows are
stunning examples of Burne-
Jones's grasp of the Gothic
aesthetic and of the color
that was Morris's signature
contribution to the firm's
stained glass production.
Morris mastered the craft of
stained glass but depended on
Burne-Jones's drawing ability
to render realistic figures.

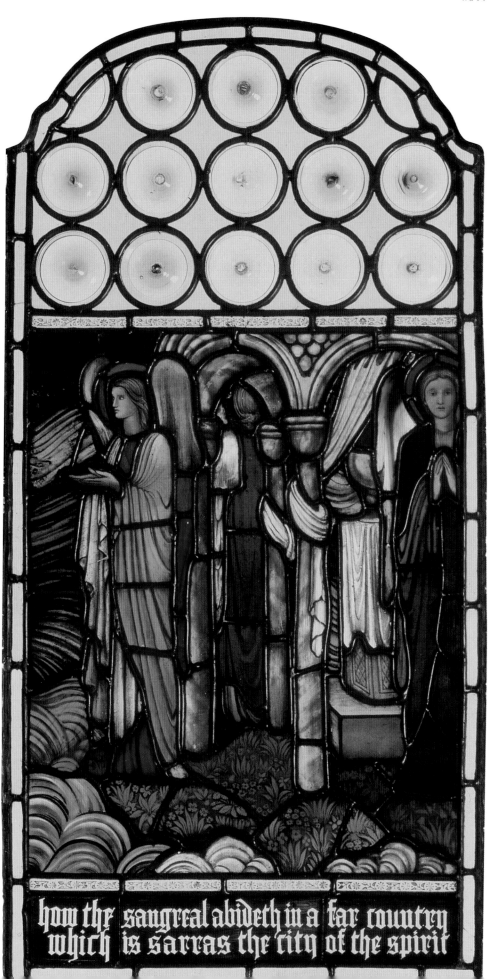

**How the Sang
Real Abideth in
a Far Country
Which is Sarras the
City of the Spirit**

*Designed by Edward Burne-Jones,
executed by Morris & Co., 1866. Victoria
and Albert Museum, London, England.*
The subject matter—
the knights of the round
table and Galahad's suc-
cessful search for the
Holy Grail—was a favorite

Summer

In collaboration with her
husband, Charles Rennie
MacIntosh, Margaret
MacDonald MacIntosh
designed murals, sten-
cils, textiles, and stained
glass. The attenuated
and highly decorative
figures in this cartoon
are typical of her style.

a reputation for lateness—the firm lost jobs
to competitors such as Clayton & Bell and
Burlisson & Grylls. In 1889, Morris turned to
book design and publishing, forming the
Kelmscott Press. Until his death in 1896, this
venture and his writing occupied him, as his
direct involvement in the day-to-day activities
of Morris & Co. decreased.

The full-scale revival of stained glass in the
nineteenth century would be unimaginable
without the contributions of Morris and the
designers and craftsmen with whom he worked,
especially Burne-Jones. Subsequent revivalists,
such as C.E. Kempe, Henry Holiday, and
Daniel Cottier, built upon the technical and
stylistic foundation provided by Morris & Co.

NATURE, MYSTICISM, AND INTERNATIONAL ART NOUVEAU

Once revived, artists started to free stained glass
from the Gothic model. Those working in more
progressive styles began to use stained glass to
express an overall design aesthetic. In the last
decade of the century, the *gesamtkunstwerk*, or
"total work of art," as expressed by Wagner and
others, was a major concern for designers who
strived to integrate all the design arts into a
harmonious whole. Architects routinely de-
signed all of the elements of an environment,
from the building itself to the furnishings,
stained glass, wallpaper, lighting fixtures, linens,
carpets, silverware, china, stationary, and even
dresses for the mistress of the house. This
kind of total harmony was inspired in part by
Japanese art and culture.

The eclecticism spawned by the revival of
older forms of ornament—such as medieval and
Celtic flat pattern designs—paved the way in
England to a positive reception for the Japanese
aesthetic and a direct link to the development of
Art Nouveau. Designers of the Century Guild

as C.F.A. Voysey in London and Charles Rennie Mackintosh in Scotland, began to produce designs for furniture, textiles, wallpaper, stained glass, and other items in styles that were less reliant on the Gothic model.

The new generation of designers was, as Morris had been, interested in joining beauty and function, yet they drew upon an expanded range of sources that included the Pre-Raphaelites, Japanese art, and the work of the visionary poet and painter William Blake, who had been nearly forgotten since his death in 1827. Rossetti rediscovered Blake. This combustible blend of sources gave rise to Art Nouveau, the style that swept the world through international expositions and through articles and illustrations in widely distributed periodicals such as London's *The Studio*, Munich's *Die Jugend*, Berlin's *Pan*, Chicago's *The Chap-Book*, Vienna's *Ver Sacrum*, Brussels's *L'Art Moderne*, and Paris's *Art et Décoration*.

Artists in Belgium were perhaps the first to take hold of the "English" style and make it their own. Brussels was a nexus of new art through exhibitions organized by Octave Maus and featuring such artists as Paul Cezanne, Georges Seurat, Odilon Redon, Auguste Rodin, Henri Toulouse-Lautrec, Vincent van Gogh, and Henry van de Velde, who eventually gave up paintings for architecture and design. A tireless self-promoter—working in Holland, Belgium, France, Germany, and Switzerland—van de Velde become one of the prime disseminators of international Art Nouveau.

One of the greatest of the Belgian Art Nouveau architects was Victor Horta, who controlled every detail of the interior decoration of the private homes he designed. Using Art Nouveau's signature whiplash line, Horta created stunningly integrated interiors. The advent of cast iron as a support material gave architects unprecedented freedom to create walls and

Door to Salon de Luxe, Willow Tea Room

CHARLES RENNIE MACINTOSH, 1903; each panel 77 x 27 in. (195.6 x 68.58 cm). Morgan Grenfell Property Asset Management, Ltd., © The Glasgow Picture Collection, Glascow, Scotland. As part of MacIntosh's total decorative program for Glasgow's Willow Tea Rooms, these doors reflect the unity of the design. The stylized rose and stringlike linear elements were repeated throughout the suite of rooms in furniture, murals, lighting fixtures, and tableware.

ceilings with decorative stained glass. New technologies in glassmaking—for example, a steam-operated roller that produced larger pieces of glass—allowed artists to design more broadly.

In Vienna, Art Nouveau was centered around the Secession, the organization of avant-garde artists who published *Ver Sacrum*. Secession artists—Gustav Klimt, Josef Hoffman, Josef Maria Olbrich, and Kolomon Moser, among them—exhibited their own work and that of local and international artists in carefully designed installations at the organization's cube-shaped building. They were among the first to recognize the talents of the husband and wife collaborators C. R. Mackintosh and Margaret

Roses and Moutettes

Jacques Gruber, 1904.

Glass panel for the Weissen Home, Nancy, France.

Gruber's atelier was in Nancy, a hot spot of Art Nouveau activity. He collaborated with Louis Majorelle, among other designers, in the production of stained glass windows and fixtures.

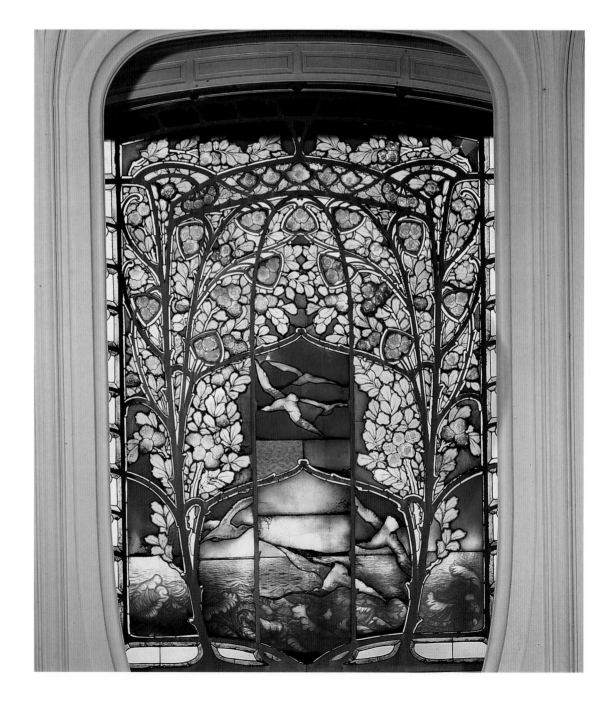

MacDonald Mackintosh. The Scottish pair's decorative designs—including furniture, murals, and stained glass—were based on botanical forms and featured highly stylized and attenuated figures inspired by Blake. They were much appreciated outside their native Scotland and had a curious affinity with the work of the Viennese avant-garde. Secession artists, like the Mackintoshs and other Art Nouveau practitioners, designed stained glass along with textiles and furniture, jewelry and metalware, and posters and books.

Another architect whose style is often described as Art Nouveau, yet whose career followed its own trajectory, was Antoni Gaudí i Cornet, Barcelona's greatest architect. Original and highly inventive, Gaudi's work is an exotic mixture of Gothic, Venetian, and Moorish elements bound together in a unity of decoration that moves with an organic rhythm. A devout Catholic, Gaudi believed that architectural forms were suffused with a mystical symbolism. His stained glass designs contribute greatly to his church interiors.

The organic and all-encompassing nature of Art Nouveau ornament was also embraced and advanced by Louis Sullivan, an American architect who trained at the École des Beaux Arts in Paris. Although Sullivan worked primarily in Chicago—his famous department store for Carson Pirie Scott & Co. in Chicago is still in use today—he also designed a number of jewel box-like banks throughout the Midwest. Like Horta, Sullivan exploited the possibilities brought about by the advent of cast iron

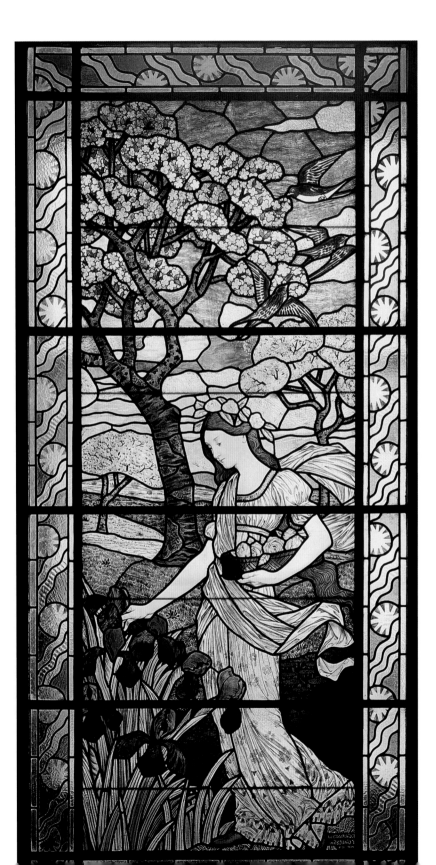

Spring

Designed by EUGÈNE GRASSET, executed by Félix Gaudin, 1884.

Musee des Arts Decoratifs, Paris, France.

A Swiss artist who settled in France, Grasset utilized
this highly decorative design in countless variations.
With the advent of iron support systems for architecture

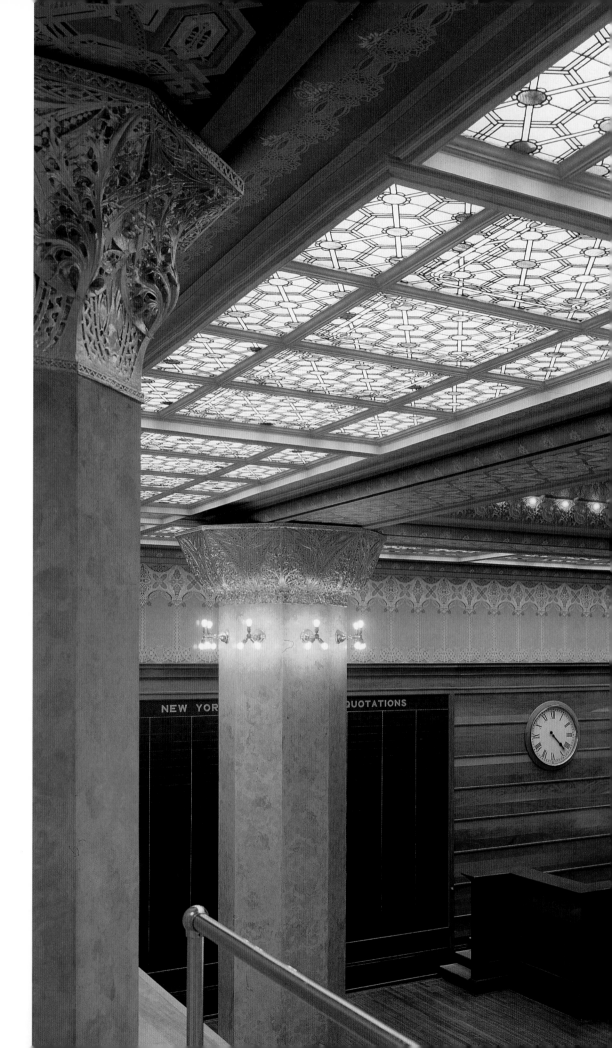

**Chicago
Stock Exchange
Trading Room**

LOUIS SULLIVAN, 1894;

skylight panels. The Art

Institute of Chicago, Illinois.

Cast iron support

systems allowed archi-

tects to design increas-

ingly larger areas of

stained glass. Here,

the patterned stained

glass joins the painted

and cast designs to

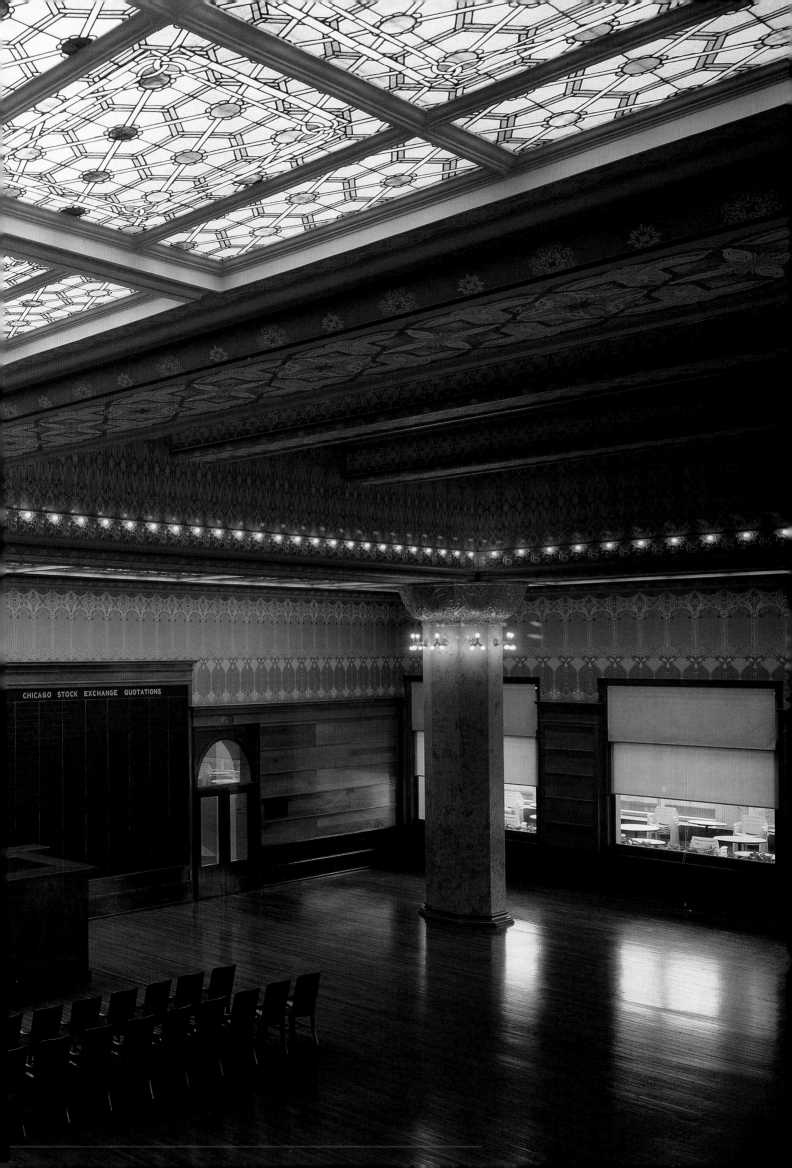

support systems and is often considered to be the father of the skyscraper. His approach to ornament was also highly influential.

To execute his decorative designs, Sullivan contracted with the firm of Healy and Millet of Chicago. Louis J. Millet worked in frescoes, stenciling, and stained glass. He was founder of the Department of Decorative Design at the Chicago Art Institute and later was head of its School of Architecture. His partnership with George Healy was both fruitful—they fulfilled many stained glass and decorative commissions in Chicago and environs—and innovative. They devised a technique known as "American Glass" to use glass fragments for background effects rather than simply paint them in as European artists generally did. A window using this technique was shown at the 1889 Paris Exposition to critical acclaim, leading other stained glass artists, Tiffany among them, to try the new technique.

One of the most determined proponents of the new style was Siegfried Bing, a prominent dealer of Japanese art and Art Nouveau objects, paintings, and furniture. Based in Paris, Bing was a generous donor of objects, including stained glass, to museums worldwide. After a visit to the 1893 World Columbian Exposition in Chicago, Bing visited Tiffany's in New York. Bing described the enterprise as:

> A vast central workshop that could consolidate under one roof an army of craftsmen representing every relevant technique: glassmakers, embroiders and weavers, case makers and carvers, gilders, jewelers, cabinet makers—all working to give shape to the carefully planned concepts of directing artists, themselves united by a common current of ideas.

Papa Chrysanthème

Designed by HENRI DE TOULOUSE-LAUTREC,

executed by Tiffany Studios, 1895. Musée d'Orsay, Paris, France.

Commissioned by Siegfried Bing, the Parisian impresario of Art Nouveau, this window was executed by Tiffany's after a design by Toulouse-Lautrec. The complex texture of the glass is typical of Tiffany's windows.

Impressed by Tiffany's interest in experimentation and his workshop's ability to carry out complex designs, Bing proposed a venture: he would secure from young French artists stained glass designs for manufacture by Tiffany's firm. Bing commissioned designs from members of the Nabis, a group of avant-garde artists who experimented with different mediums in the execution of their flat, simple compositions.

To advance his idea of a "new Art," Bing renovated his gallery; developed an atelier for designers to produce ceramics, jewelry, metalwork, textiles, and furnishings; and organized traveling exhibitions of contemporary wares, including stained and blown glass from his gallery and Japanese art from his collection. Bing's gallery regularly displayed Tiffany's blown glass vases and bowls and the occasional stained glass window. He also carried furniture and glass from the School of Nancy, a center of Art Nouveau activity. Louis Majorelle, the Daum Brothers, and the enormously successful Emile Gallé produced furniture and glass in a swirling, organic style.

Peacocks & Peonies II

Detail; JOHN LA FARGE, 1882.

National Museum of American Art, Washington, DC.

This detail shows the effect of cast opalescent glass. The peonies are articulated by single pieces of streaked glass that uncannily suggest the form of the flower.

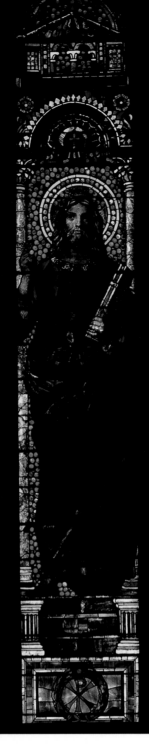

Christic in Majesty

JOHN LA FARGE, 1883. Trinity Church, Boston, Massachusetts. Trinity's rector asked for something inspiring to look at while he preached. Obligingly, La Farge borrowed this composition from a portal statue at Amiens. Bing remarked on its "astonishing brilliance" and said the window "surpasses anything of its kind in modern times."

TIFFANY, LA FARGE, AND THE POPULARIZATION OF STAINED GLASS

A love and affinity for stained glass and entrepreneurial acumen also characterized the career of Louis Comfort Tiffany (1848–1933). Like Morris, and inspiring Bing, Tiffany founded a successful firm that provided full-service design for both public and private settings. Tiffany capitalized on technical innovations in stained glass and is primarily responsible for enlarging the market for domestic stained glass windows and decorative objects. His compatriot John La Farge (1835–1910) was the first, however, to patent the opalescent glass that is sometimes

associated with Tiffany and is known today as "cathedral" glass or "Kokomo" glass after the town in Indiana where it is manufactured.

La Farge was a multi-talented artist of much originality whose travels to the Far East instilled in him a love for the exotic. Born in New York to wealthy French parents, La Farge pursued the life of an artist, training in Paris with Thomas Couture. La Farge gave up easel painting in order to devote himself to murals and decorations. His collaboration with architect H. H. Richardson on the decorative scheme for Boston's Romanesque-style Trinity Church caused a sensation and garnered critical acclaim. It brought La Farge to the public's

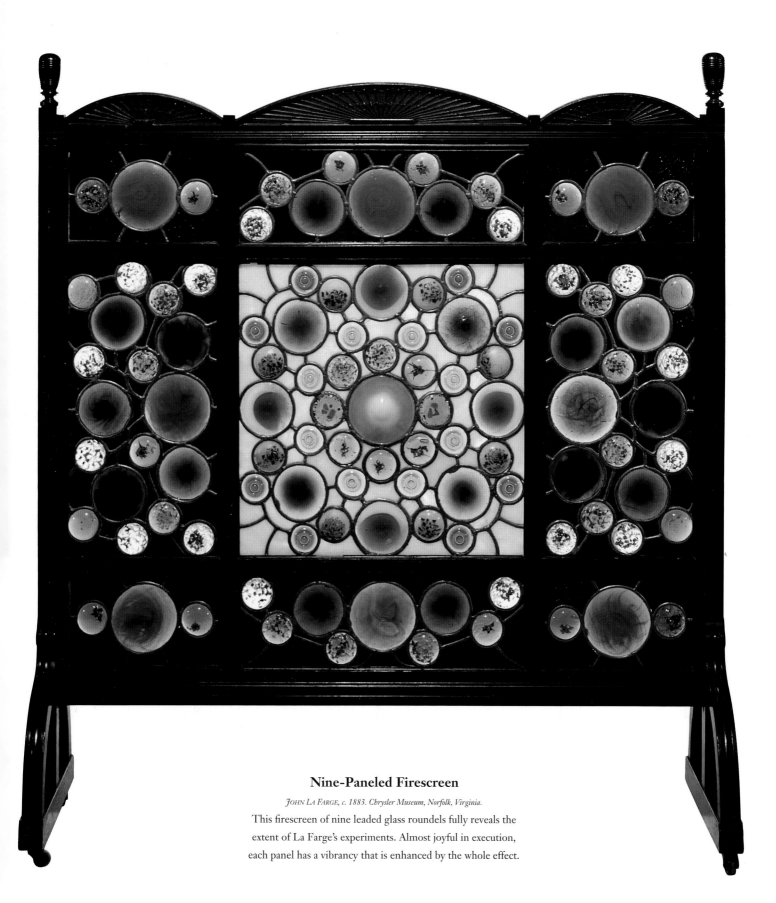

Nine-Paneled Firescreen

JOHN LA FARGE, c. 1883. Chrysler Museum, Norfolk, Virginia.

This firescreen of nine leaded glass roundels fully reveals the
extent of La Farge's experiments. Almost joyful in execution,
each panel has a vibrancy that is enhanced by the whole effect.

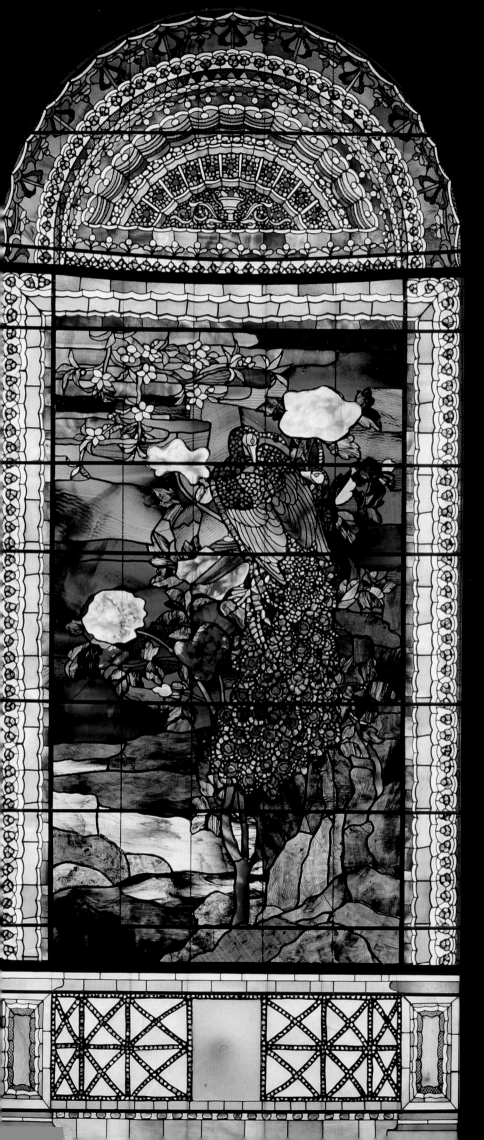

Peacocks and Peonies I & II

JOHN LA FARGE, 1882.

National Museum of American

Art, Washington, DC.

This pair of windows
was designed for a huge,
oak-paneled hall in the
Boston home of Frederick
Lothrop Ames. Within
their architectural frame-
works, the two windows
anchored the west wall.
It has been suggested
that the compositions
were derived from
Ming Dynasty scrolls
in La Farge's possession.

attention as easel painting never had
became increasingly well-regarded as a
rator and garnered numerous ecclesiastic
domestic commissions.

La Farge was forty-one years old by the
he took up stained glass. He approache
medium as a painter and was interest
achieving effects of space and modulatio
color. This was in contrast to the art of N
and his circle, who were intent on replic
the medieval style of flat planes of color w
spatial depth. La Farge began experime
with glass after he happened to see again
light a cheap glass toiletry jar made to in
porcelain. The artist was struck by the o
cent quality of the glass and felt he had
the right material to achieve his desired e
in stained glass.

In 1880, the year his patent for opale
glass was obtained, La Farge was contract
a New York decorating firm, Herter Bro
to supply the stained glass windows for the
houses they were decorating. With each
mission, La Farge advanced and refine
signature style: an eclectic mixture of dif
types and textures of glass, from the tiny
or "broken jewels," to molded and presse
metal and opalescent glass and the inclus
bits of different materials such as semipre
stones and broken bottles.

In his ongoing search for ways to "pai
stained glass, La Farge pursued a method,
"cloisonné glass," that joined tiny pieces o
through thin wire fused into the glass.
process allowed for modeling faces in deta

The Infant Bacchus

JOHN LA FARGE, 1882–1884; 89 1/8 x 44 7/8 in. (2.26 x 1.14 m).

Gift of Washington B. Thomas, Museum of Fine Arts, Boston, Massachuse

Inspired by Burne-Jones to try stained glass, La Far
moved far away from the simplicity of the Gothic
models. In this lush, painterly composition, based
on a snapshot taken at a garden party, La Farge
pushed the boundaries of stained glass to an extrem

Apple Blossom Window

LOUIS COMFORT TIFFANY, n.d.

Virginia Museum of Fine Arts.

Tiffany began as a painter of color-rich landscapes but was soon entranced with the medieval stained-glass windows of European churches. His sinuous lines and intense colors are classic examples of the Art Nouveau style.

costly and complicated, few windows were produced using this method. La Farge's work with opalescent glass and his success in achieving painterly effects attracted much attention, especially from Tiffany, who was also pushing the boundaries of stained glass. While La Farge's approach to stained glass was very much the hands-on style of a painter, Tiffany approached the medium as a designer and businessman, building a large and influential stained glass industry.

Tiffany, like La Farge, had been an easel painter before turning his attention to design. Born to a wealthy family (his father, Charles, founded the jewelry firm Tiffany & Co.), the younger Tiffany studied painting in Paris and traveled to Spain and North Africa. After returning to New York, the artist burst on the scene as a decorator when he formed, in 1881, Louis C. Tiffany and Associated Artists with Samuel Coleman and Candace Wheeler, a talented textile designer. Many of the firm's

commissions came through Richardson's protégé and Tiffany's friend, Stanford White, whose own firm—McKim, Mead and White—was growing.

Many have noted the influence of the Gothic revival on Tiffany. The artist was, however, amazingly eclectic, and drew from an astounding number of sources—Islamic, East Indian, and Asian among them. Commissions rolled in and Tiffany counted among his clients Cornelius Vanderbilt II and the White House. There, Tiffany and his associates were engaged in 1882 to provide alterations and furnishings. The major attraction was an opalescent glass screen in the first floor hall. Designed to provide privacy for the president and his family, the screen was ordered "broken into pieces" by Theodore Roosevelt during Charles McKim's 1904 neo-classical renovations to the White House. Unfortunately this was a fate suffered by a large number of the interior screens and windows designed by Tiffany.

FOLLOWING PAGE:

Landscape

Tiffany Studios, n.d.
Private Collection.

Tiffany's windows for domestic settings often depicted landscape views receding into the distance. Here, framed by hollyhocks, irises, a grape arbor, and architecture, the view evokes a window's perspective. The window's painterly effects are achieved through the artful selection of opalescent glass pieces.

Apple Blossom Window

Detail; Tiffany Studios, n.d.
Virginia Museum of Fine Arts.
The artisan's hand can be seen in this detail of a Tiffany window. The selection of glass—chosen here to replicate the mottled effect of sunlight through branches—was an important key to the beauty of a Tiffany window.

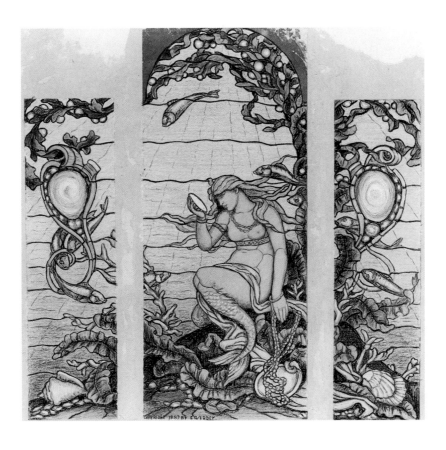

The Mermaid Window

ELIHU VEDDER, c. 1882–1887;
crayon and gold on paper.
Cooper-Hewitt Museum,
Smithsonian Institution's National
Museum of Design, New York.
This cartoon is for a stained glass window to be executed by Tiffany's firm. The artist has depicted a watery, undersea scene featuring pearls—undoubtedly intended to be rendered in opalescent glass.

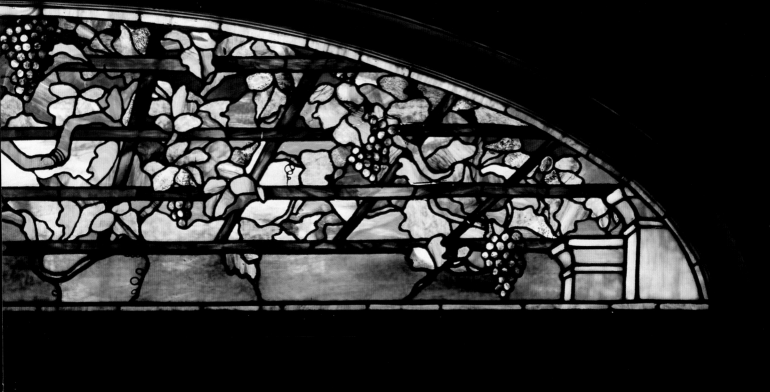

Daffodil Lamp

Tiffany Studios. leaded glass, bronze base. Art Trade, Bonhams, London, England.

Designers at Tiffany Studios were encouraged to experiment with style and technique. They produced a dizzying array of products, from lamps to windows to clocks.

After the dissolution of his partnership with Coleman and Wheeler, various reversals of fortune, and the death of his wife in 1883, Tiffany's life reached a turning point. The elder Tiffany, concerned about his son and the well-being of his grandchildren, decided to build a house for the extended Tiffany family and appointed Louis head of the project. The huge Richardsonian manse designed by Stanford White was a spectacular setting for entertaining clients and played a role in garnering more commissions and visibility for the firm. Re-energized, the younger Tiffany formed the Tiffany Glass and Decorating Company, catering primarily to architects. To fulfill the growing number of commissions and increased demand for stained glass windows, the firm

added additional designers. Tiffany's time was spent primarily attending to business matters, with little time for designing. He did attend to a few special windows and decorative commissions, such as the complete decorations—including stained glass windows and fixtures—for the Havemeyer's new mansion. Fabulously eclectic in sources but harmonious in execution, the mansion's decor caused a sensation.

The firm continued to expand and its various offshoots consolidated as Tiffany Studios. The firm added new departments of furniture, ceramics, metalwork, jewelry, enamels, and blown glass products from the Tiffany Furnaces in Corona, Queens, where Tiffany's famous "favrile," or iridescent glass, was manufactured. The expanded product lines—a dizzying array of household accessories, including lamps, desk sets, ashtrays, tableware, clocks, and vases—were displayed in the firm's showrooms and in those of his father's firm, Tiffany & Co.

Depending on the needs of the clients and the talents of the designers, Louis Tiffany's company was able to produce stained glass windows and lamps in a variety of styles. This range of production could only have occurred in the workshop atmosphere that he engendered at Tiffany Studios, where men and women were encouraged to stretch and experiment in style and technique. Production at the firm was shut down in 1928. Today, the Louis Comfort Tiffany Foundation still administers a program of grants to young artists, continuing Tiffany's interest in nurturing young talent.

"Dragonfly" Lamp

Tiffany Studios, designed by Clara Driscoll, 1900; leaded glass, bronze base; h. 75.6 cm., d. 55.9 cm. The Chrysler Museum at Norfolk, Norfolk, Virginia.
Clara Driscoll was once one of the highest paid female designers in the country. An award-winner at the Paris Exposition, this lamp was one of Tiffany's most popular; one could also purchase a delicate dragonfly "pendant" on a chain to hang from the shade.

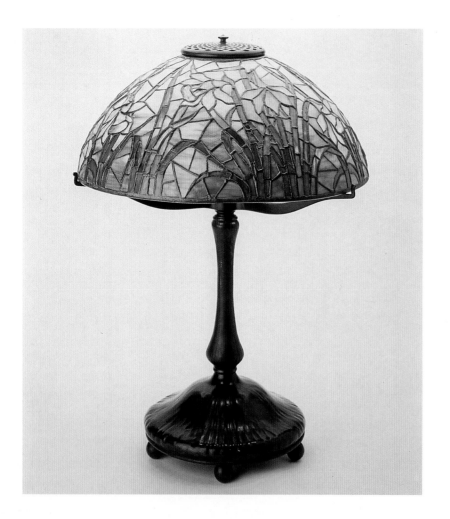

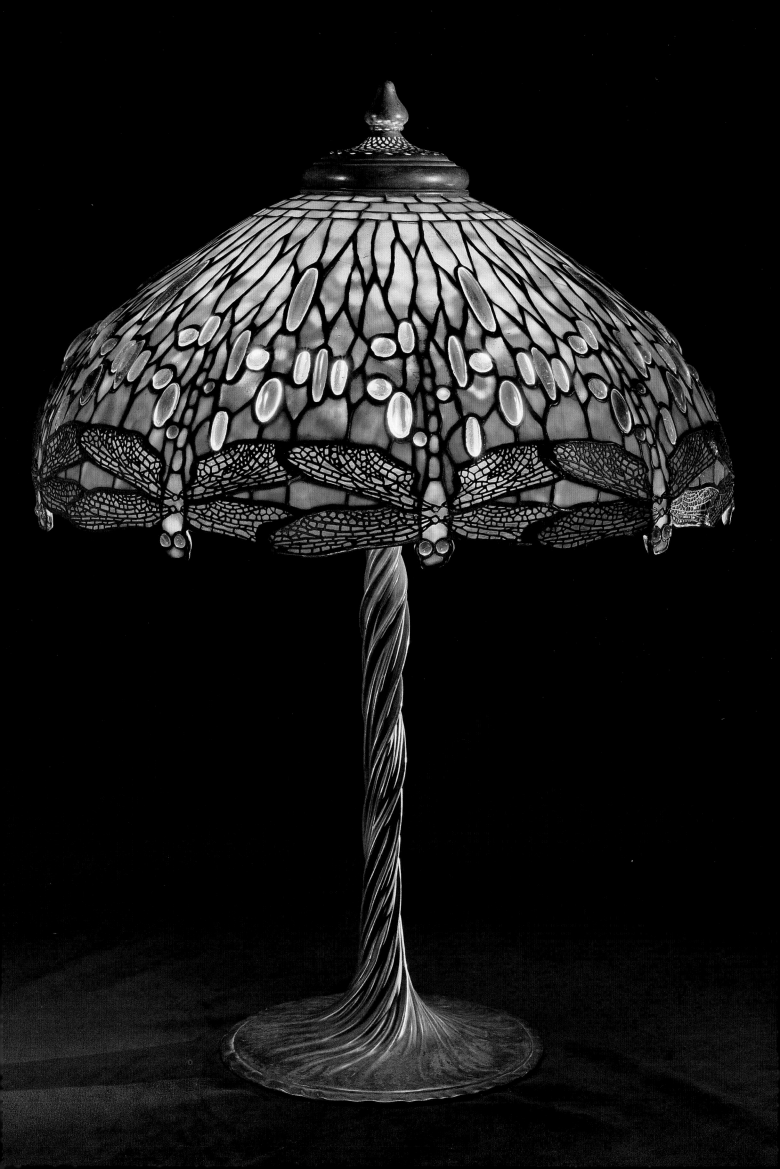

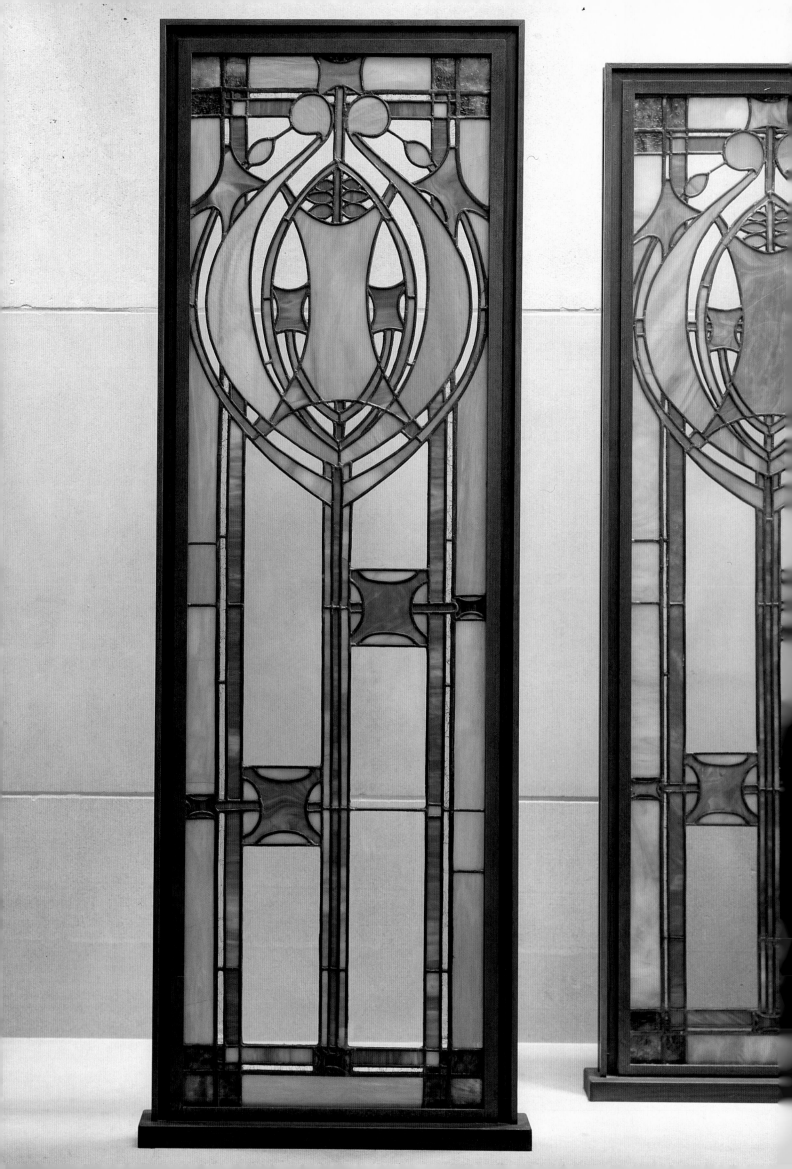

Stained Glass and the Modern Age

A Century of Change

In the twentieth century, the world saw unprecedented advances in science and technology—penicillin, the polio vaccines, motion pictures, radio and television, airplanes and automobiles, telephones and computers. Art Nouveau and the Arts and Crafts movement dissolved in the first half of the century, and the arts and design fields roared with dada and deco, surrealism and purism, and the birth of an international style.

After World War II, an arts and design renaissance dovetailed with an architectural explosion in the rebuilding of a shattered Europe and a defeated Japan. Emerging in the postwar era as an economic and ideological superpower, the United States enjoyed a era of strength and prosperity through the 1950s and 1960s. Art and design reflected the optimistic exuberance of period, and glass art moved into a new period of experimentation and broader public interest. The modern studio glass movement was founded, and art schools began to include glassworking courses in their curricula. On a more informal front, the "high art" of stained glass was popularized as a home craft. Hobbyists could produce their own light-enhanced emblems of individual creativity.

Artists and Craftsman of Stained Glass

At the turn of the century, the ideology of the Arts and Crafts movement still held sway in America; its greatest flowering came between 1890 and 1910. By the early 1920s, it was clear that the movement in America had two paths: a conservative one and a progressive one. The conservative and anti-modernist segment longed for the past and revived styles evocative of the pre-industrial age such as Spanish, Gothic, Tudor, and Colonial, the latter serving an urge towards nationalism. Many of the decorative firms that specialized in stained glass continued to operate well into the century, satisfying the demand for memorial windows for churches and colleges.

The progressive wing of the Arts and Crafts movement embraced machinery, rejected the academy, and advocated for a democratic vernacular based on simplicity and abstraction. These artists often drew from Native American and other reductive design sources. Avid consumers of international art and design magazines such as *International Studio*, *Dekorative Kunst*, and *Art et Décoration*, the more forward-looking practitioners of the Arts and Crafts ethic responded to the advanced European and English designs reproduced in the periodicals.

Both paths, however, were characterized by the development of strong regional styles spawned by art colonies and guilds—such as Roycroft in East Aurora, New York, and Stickley's Craftsman Workshops in Syracuse—or simply the influence of dominant personalities like Frank Lloyd Wright, who with George

Window

GEORGE GRANT ELMSLIE, 1911; leaded glass; 63 x 15 in. (160 x 38.1 cm). Metropolitan Museum of Art, New York; Gift of Roger G. Kennedy, 1972. While working in Louis Sullivan's firm, George Elmslie was often responsible for the elaborate decorative programs of Sullivan's buildings. This panel dates from Elmslie's later partnership with William Purcell, and is typical of the Prairie School's geometric design and liberal use of clear glass.

Design for a Three-Part Window for a Mortuary in Vienna

*DARD HUNTER, c. 1909;
architectural drawing; watercolor
and ink on board; each panel
11⅝ x 4 in. (29.53 x 10.16 cm).
Metropolitan Museum of Art,
Edward Pearce Casey Fund, 1982.*
Dard Hunter's designs
for Roycroft were
particularly distin-
guished after his trip
to Vienna and London.
the extreme stylization
of figures and the
reductive rose motif
evince the artist's
familiarity with the
designs of both Mac-
Intosh and the Vienna
Secession group.

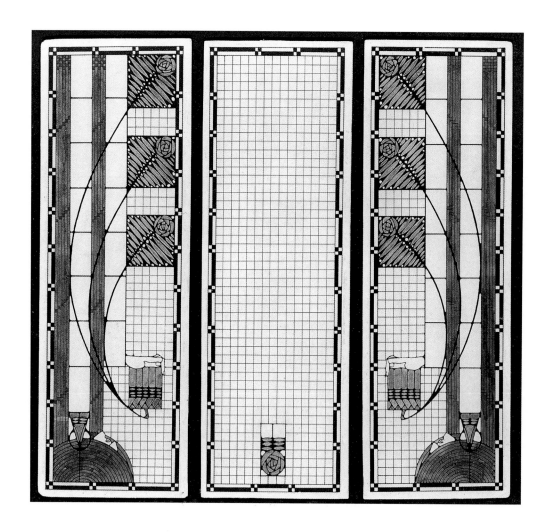

Ceiling Light

*CHARLES SUMNER GREENE
and HENRY MATHER GREENE,
c. 1907–1909; mahogany and
stained glass; d. 28½ x 25½ in.
(72.39 x 64.77 cm).
Robert R. Blacker House,
Pasadena, California.*
This lamp is typical
of the mature style
of Greene & Greene.
Distinctly Asian in form,
the lamp was probably
made by Emil Lange,
formerly of Tiffany
Studios, whose firm
flourished in Los Ange-
les around 1905–1915.

Elmslie, Henry Purcell, and others, formed the Prairie School in the Midwest. In California, as elsewhere, stained glass was practiced in work-shops along with work in other mediums such as ceramics, metalwork, cabinetry, embroidery, weaving, and batik. Among the most talented of the modern Arts and Crafts designers in Cali-fornia were the architect brothers Greene and Greene, whose love and respect for materials and excellence made their signature style.

Born in St. Louis and trained at the Massa-chusetts Institute of Technology, Charles Sum-ner Greene and his younger brother, Henry Mather Greene, moved to Pasadena, where they set up an architectural practice. For ten years, the brothers designed houses in a range of revival styles before articulating their own unique vision, which was infused with the

Orient and obsessed with detail in craftsman-ship. Charles Green collected oriental books, prints, and furniture, which greatly informed the style developed by Greene & Greene. Their work featured an integrated architecture—harmony among building, furnishing, and landscape—with the beauty of materials at its center. Greene & Greene designs reached the height of expression in a series of houses—including the Robert Blacker house of 1907 and the David B. Gamble house of 1908—that have been regarded as the "ultimate bungalows."

These mature house designs called for cus-tom-designed and -produced furniture, lighting fixtures, stained glass, hardware, fireplace tools, carpets, curtains, fabric, and garden pottery, all made by craftsmen to the Greenes's speci-fications. The brothers maintained close

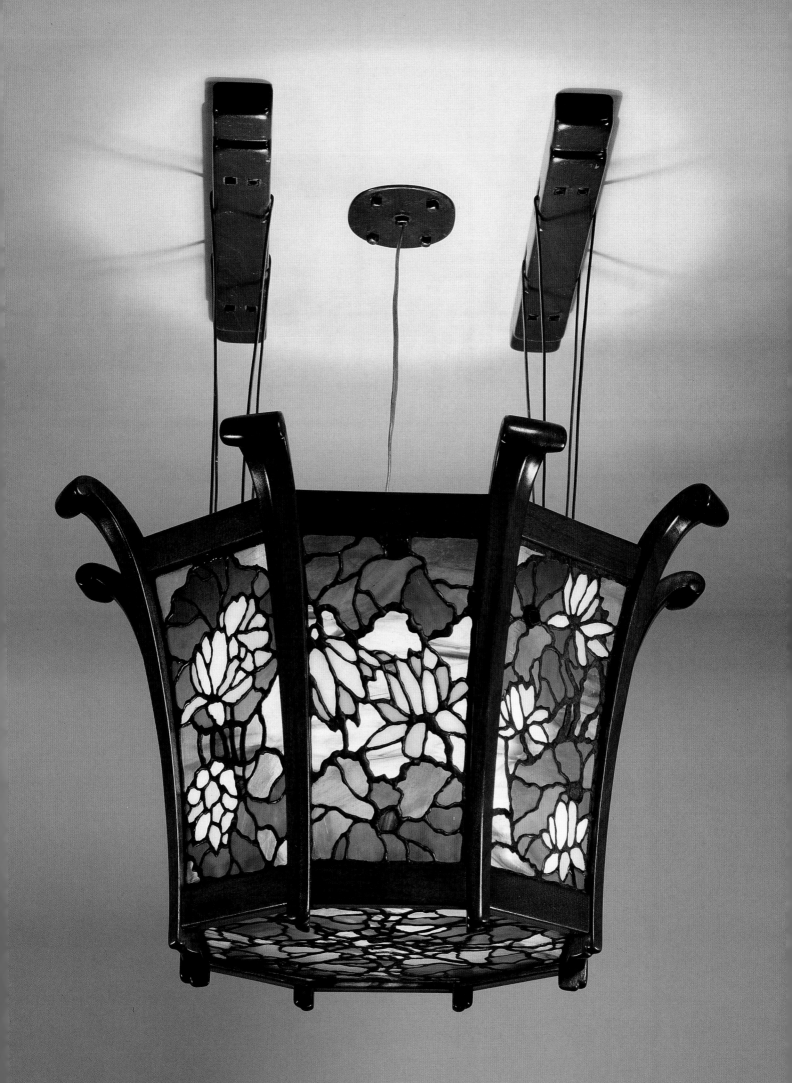

Ceiling Light

Detail; CHARLES SUMNER GREENE and HENRY MATHER GREENE, c. 1907–1909;

mahogany and stained glass; d. 28½ x 25½ in. (72.39 x 64.77 cm). Robert R. Blacker House, Pasadena, California.

This lamp from the Blacker House is just one of many custom-designed and -crafted details that reflect the total integration of building, furnishing, and landscape that was the signature of the Greens's "ultimate bungalow" style. The stained glass lilies echo those found in the pond in the rear gardens of the house.

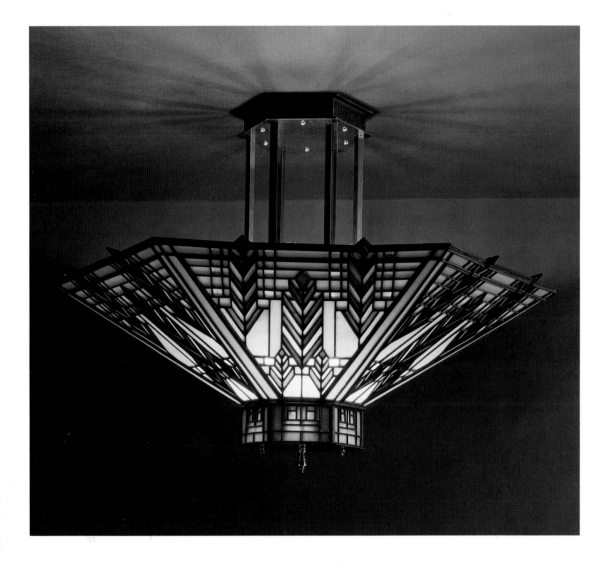

Chandelier

Designed by ARTHUR HUEN, executed by Giannini and Hilgart Glass Company, Chicago, c. 1901–1902; stained glass and brass; from the S. S. Brinsmaid Residence, Des Moines, Iowa. Metropolitan Museum of Art; Gift of Russell L. O'Hara, 1974.

The geometric forms of Prairie School stained glass were less time consuming and therefore less costly to produce. Designers often relied on a great degree on those who executed the stained glass—such as Giannini and Hilgart Glass Company, who also produced stained glass for Frank Lloyd Wright—and sometimes led to cross influences among designers through the technicians.

relationships with the same trusted craftsmen. Meticulously detailed stained glass windows, doors, skylights, and electric light fixtures and lamps were crafted for the Greenes by Emile Lange. Formerly with Tiffany Studios, Lange was partner with Harry Sturdy in the Sturdy-Lange Studios, an architectural and decorative stained glass firm that thrived in Los Angeles from 1905 to 1915. The stunning work Lange executed in glass for the Gamble House is one of the outstanding features of the house, contributing through lighting effects to the overall mystery of the environment. Interest in the Greenes's designs faded and their work began to seem dated in the wake of modernism. In the post-war period, however, a resurgence in interest in natural materials, along with a series of published studies of their work, drew new interest in the Greenes.

Since Tiffany had turned stained glass to the service of lamps—at first oil and then electric—more and more artisans began to design electric lamps. Along with many other home accessories, lamps were produced and retailed by the colonies and guilds. Articles in various crafts magazines abounded with technical information for the amateur on the crafting of stained glass windows, lamps, and shades, along with other how-to features on crafts such as cabinetmaking and embroidery.

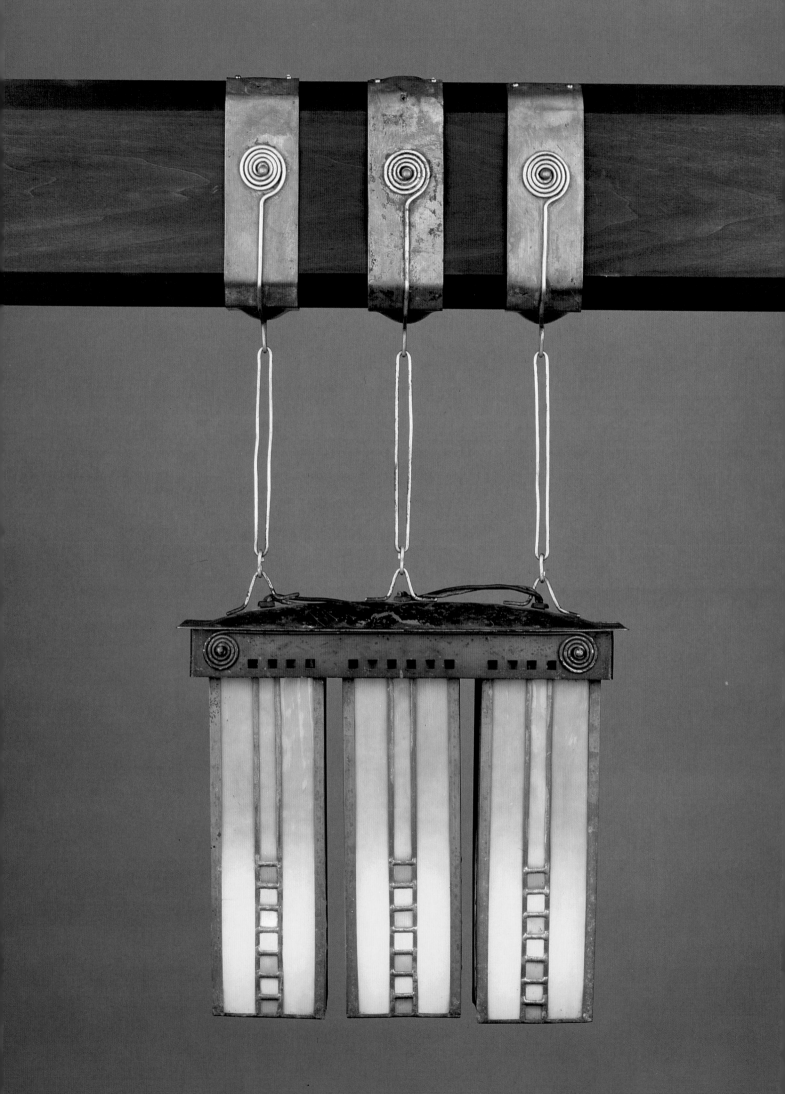

Dard Hunter, who designed stained glass lighting fixtures for the Roycroft Inn and Shops—the guild's tourist housing and retail outlet—offered a stained glass correspondence course, "Things You Can Make," through the Roycrofters. Hunter was imbued early on with an interest in books and design and moved in 1903 to the Roycroft colony, where he expressed an interest in learning stained glass techniques. The guild's founder, Elbert Hubbard (1856–1915), sent him to New York to work with J. & R. Lamb, a firm specializing in church interiors and stained glass. Hunter returned to East Aurora and designed stained glass windows, lampshades, and lighting fixtures, using glass from the Opalescent Glass Works in Kokomo, Indiana. His early work in stained glass ranks among the finest of the Arts and Crafts movement.

One of the most protean figures associated with the Arts and Crafts movement was Frank Lloyd Wright (1867–1959), who came of age in Louis Sullivan's firm in Chicago. An architect and designer of singular genius whose designs ranged from the long and low Prairie-style houses to the spectacular Falling Water for Edgar Kaufman and the unique Guggenheim Museum in New York, Wright had a career that spanned some 70 years. Wright used stained and leaded glass extensively in the period from about 1898 to 1912, after which he primarily used clear plate glass. During this early period, however, Wright freely used stained and leaded glass for windows, doors, skylights, and lighting fixtures in harmony with the custom designs for furniture, textiles, china, and other accessories that accompanied some of his more important domestic commissions.

Wright was enamored of the machine and particularly appreciative of its role in producing good quality and inexpensive glass. He felt that glass, more than any other architectural

Lighting Fixture for the Roycrofter Inn

DARD HUNTER, 1903–1908; copper, German silver, and stained glass; 30 x 16 x 6 in. (76.2 x 40.64 x 15.24 cm). Harriet Otis Cruft Fund, courtesy Museum of Fine Arts, Boston, Massachusetts.

This stunning example of Arts and Crafts handiwork was most probably a collaboration between Hunter and the Roycroft master coppersmith. The two often worked together to produce decorative items for the Roycrofter Inn and for sale in the

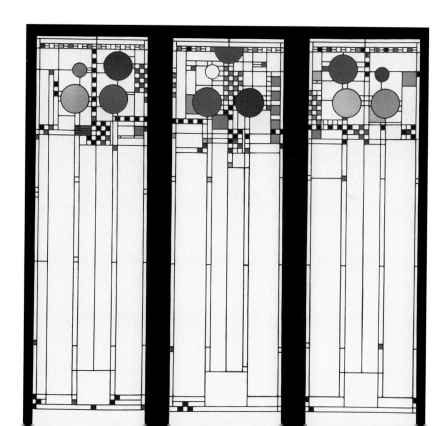

Three Windows from the Avery Coonley Playhouse

FRANK LLOYD WRIGHT, 1912; leaded glass, wood frame; 86¼ x 28 in. (219.07 x 71.2 cm). Metropolitan Museum of Art, New York; Edward C. Moore Jr., gift of Edgar J. Kaufman Charitable Foundation Fund, 1967.

These windows for the Coonley's experimental education annex were among the first in which Wright utilized circles and, in the ratio of colored to clear glass, foreshadow the architect's move away from stained glass.

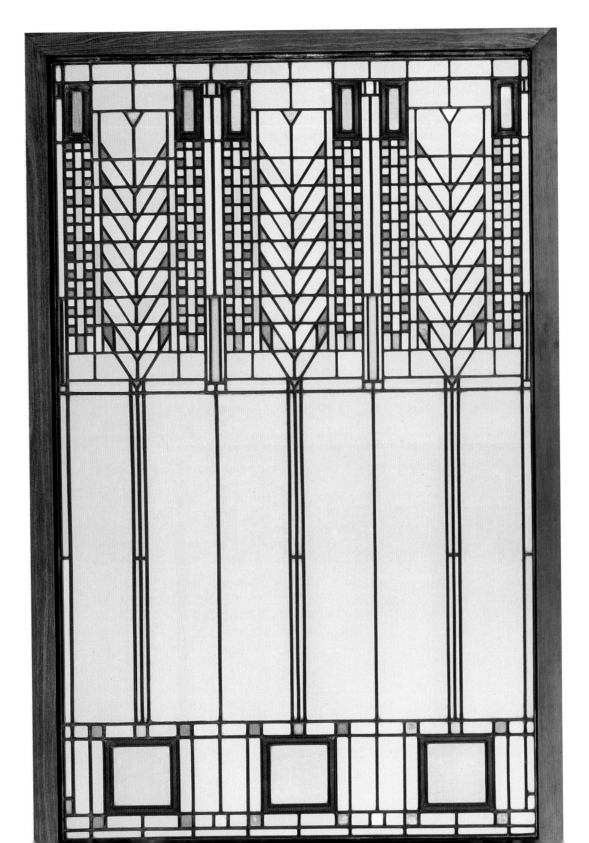

Tree of Life Window

FRANK LLOYD WRIGHT, *stained glass*
window for Martin House, c. 1904.
The Art Institute of Chicago, Illinois.
Frank Lloyd Wright
designed every aspect of the
homes he created, from the
overall building plan down
to the furniture and
windows. He used stained
glass to infuse rooms with
colorled light, filling the
spaces with a hearth-like
warmth.

Fan Light

Detail; Susan Lawrence Dana House,
designed by FRANK LLOYD WRIGHT, c.
1900. Springfield, Illinois.
Wright felt that glass
introduced light and pattern
into a space better than any
other architectural material,
and he worked extensively
with both clear and stained

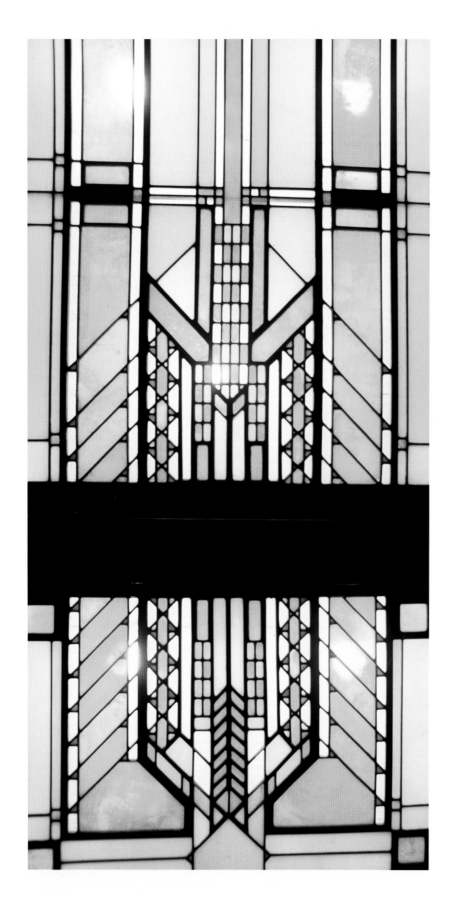

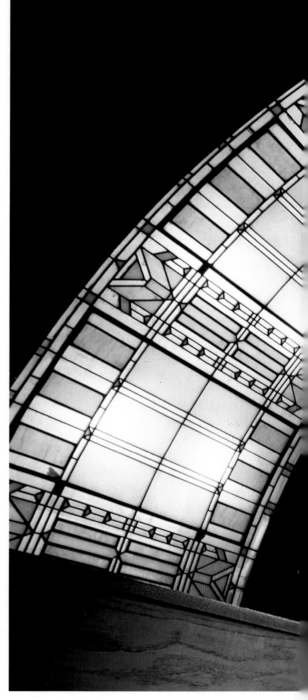

Entry Barrel Vault, Susan L. Dana House

FRANK LLOYD WRIGHT, c. 1900. Springfield, Illinois.

Wright's house for Susan Dana contains the most elabo-
rate stained glass decorative program of any of his houses.
In sheer quantity alone, the house glows with stained glass
from top to bottom. The differences seen here in the
barrel vault and fan light shows the complex yet unified
nature of Wright's stained glass scheme for the Dana home.

Detail, Susan Lawrence Dana House

FRANK LLOYD WRIGHT, c. 1900. Springfield, Illinois.

The stained glass for the Dana House was bound
by a common palette and a geometric abstraction
based upon natural plant forms. Wright experimented
with different kinds of came—extra-wide versions were
new to the market—to contribute to the composition.

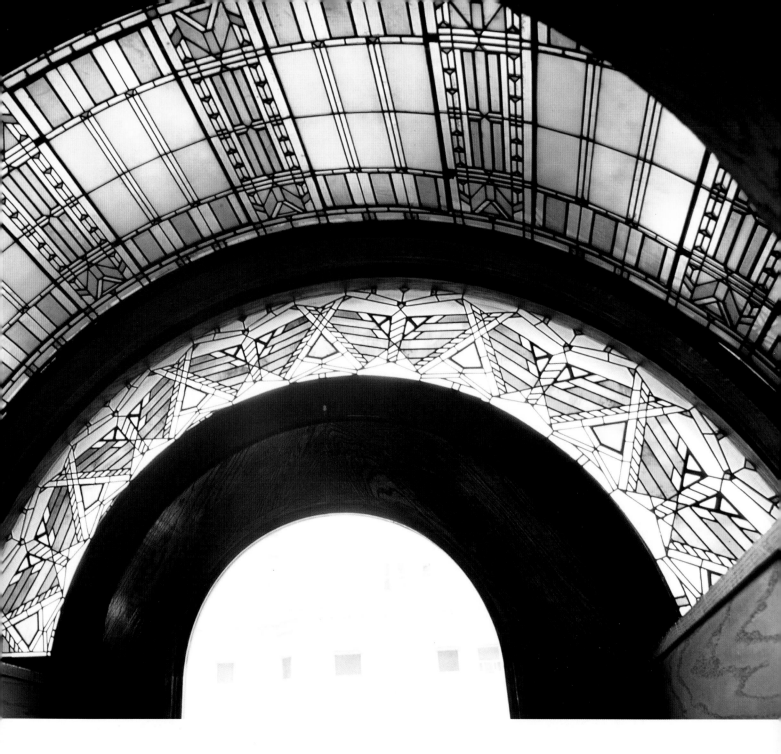

material, offered the most expressive and cost-effective means to introduce pattern into a space and create special effects of light. Wright's rectilinear style—most often based on abstractions of plant motifs— also lent itself to a less labor-intensive production.

Always an innovator, Wright experimented extensively with leading, pushing it towards pure design. By varying the width of the came and plating it with different materials, Wright used it as a distinct decorative element. For windows, Wright favored transparent glass and preferred to keep his designs simple and abstract, so as not to disturb the view outside. He expressed his views in a 1928 essay on glass for *Architectural Record*: "Nothing is more annoying to me than any tendency towards realism of form in window glass, to get mixed-up with the view outside. A window pattern should stay severely 'put.'"

The house designed for Susan Lawrence Dana in 1899 includes Wright's most ambitious and extensive program of stained and leaded glass. In addition to the staggering amount of built-in glass—skylights, soffits, fan windows, floor fixtures with light from the basement, and an elaborate, sculptural fountain surrounded by glass panels—Wright designed his first three-dimensional stained glass pieces, dining room fixtures, and table lamps. All the glass in the Dana House was produced by the Linden Glass Company in Chicago, a firm that worked frequently with Wright in executing his designs.

FOLLOWING PAGE:

Peace

Detail from Hadassah Hospital;
MARC CHAGALL, c. 1962.
Jerusalem, Israel.
Representing each of the tribes of Israel, the twelve Jerusalem windows Chagall designed for the synagogue of the Hadassah-Hebrew University Medical Center are remarkable for their color and rhythmic leading.

Kaiserlich

*JOSEF ALBERS, c. 1923; glass
assemblage in lead support;
18⅞ x 19¼ in. (47.94 x 48.90
cm). Gift of the Josef Albers
Foundation, 1980, Josef Albers
Museum, Bottrop, Germany.*
At the Bauhaus,
Germany's leading
school of design reform,
the stained glass section
was by headed by Paul
Klee and Josef Albers.
In this work, Albers
has used different kinds
of glass—molded and
chipped, industrial
"ripple" glass, and dia-
mond ruby glass—to
construct a beautifully
textured abstraction.

MODERN ARTISTS, STAINED GLASS, AND THE POST-WAR BUILDING BOOM

As the Arts and Crafts style waned worldwide, the cutting edge of design reform shifted to Germany. Modeled on the design schools that helped to spawn the English Arts and Crafts movement, the Bauhaus was a place for young artists and designers to immerse themselves in a variety of disciplines. The Bauhaus stained glass workshop was relatively short-lived. Headed first by Paul Klee, then by Josef Albers, it was dropped from the curricula in 1933.

Abstraction in stained glass, born in Frank Lloyd Wright's work, was furthered by the Bauhaus and by Theo van Doesberg, who founded with Piet Mondrian "de Stijl," a Dutch avant-garde group. For the 1926 decoration of Strasbourg's Cafe L'Aubette, van Doesberg enlisted Jean Arp and his wife, Sophie Taeuber, to help design stained glass, the majority of which is now lost. During the

1920s and 1930s, stained glass was dominated by work by artists in the circle of Johann Thorn Prikker. A Dutchman who taught at a number of German art academies, Thorn Prikker was part of the symbolist movement but under the influence of van de Velde; he gave up painting in favor of design, first working a cubist style then in an expressionist vein. Through his students Anton Wendling and Heinrich Campendonk, Thorn Prikker's legacy continued after his death in 1932.

Following the war, a surge of worldwide building occured. Whether to reconstruct or to reinvigorate the economy, massive building campaigns resulted in a wave of stained glass commissions, both religious and secular. The need to restore damaged cathedral windows and to replace lost ones was fulfilled through commissions of stained glass cartoons or programs from painters such as Henri Matisse, Georges Roualt, Marc Chagall, and Fernand Leger. This stimulated the continuity of stained glass traditions and revived workshops in some of the great cathedral towns of Reims and Chartres. Chartres remains an important center for glassmaking activity and has been the host of international exhibitions of contemporary stained glass.

Some craftsmen in stained glass were creators as well, and painters such as Alfred Manessier turned increasingly to stained glass after their first commissions. In Europe and the United States, stained glass artists worked in new styles—expressionism, abstraction, and pop among them— and used new technologies. The advent of *dalle de verre*, or slab glass, allowed artists to cast glass into concrete, thereby strengthening its support and freeing the design to span entire walls of glass, such as the spectacular stained glass tower at the Modern Art Museum near Tokyo by Gabriel Loire of Chartres.

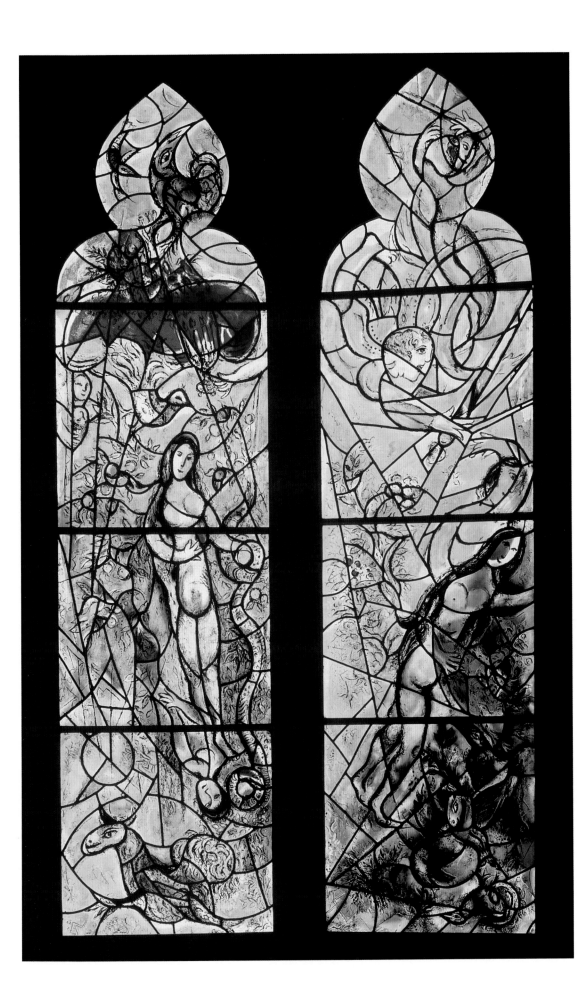

Eve & the Serpent; Adam & Eve Driven from Paradise

Designed by MARC CHAGALL, executed by Marq and Brigitte Simon; Metz Cathedral, France. Chagall's series of windows for the ambulatory at Metz were executed by Charles Marq and Brigitte Simon, who carried out all of Chagall's international commissions. Based in Rheims, their workshop continued the great tradition of stained glass workmanship established there in the thirteenth century.

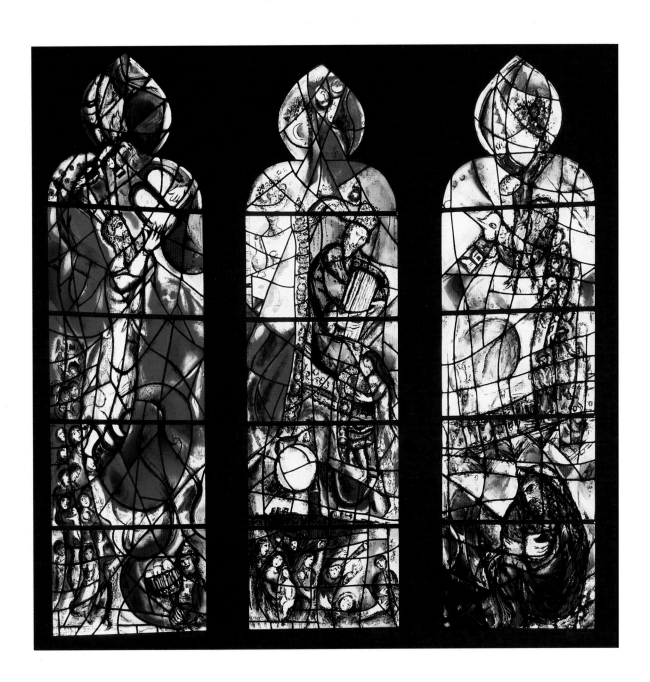

Front Door Panel

Detail from the Edna S. Purcell House; designed by WILLIAM GRAY PURCELL

and GEORGE GRANT ELMSLIE, executed by E.L. Sharretts of the Mosaic Art

Glass Company, c. 1913; stained glass and zinc; 89 x 19 in. (226.06 x 48.26 cm).

Gift of Anson B. Cutts, Minneapolis Institute of Arts, Minneapolis, Minnesota.

Elmslie and Purcell, along with Frank Lloyd Wright and others, constituted the Prairie School of design. Centered in the Midwest, they produced furnishings, including stained glass pieces, that combined geometric simplicity with a natural aesthetic.

Moses Receiving the Tablets of the Law *(left)*, David and Bathsheba *(center)*, and The Exodus *(right)*

Marc Chagall, c. 1960–65. Metz Cathedral, France.

Chagall began working in stained glass late in live, launching a career in the new medium when he was in his seventies. The dream-like imagry of his paintings translates perfectly into stained glass.

Stained Glass Window Wall

Twentieth century. Caracas Airport, Venezuela.

While stained glass has been used for centuries as a medium for portraiture and storytelling, modern approaches often use more abstract patterns for architectural purposes. The cool, soothing colors of this huge stained glass wall fill a cavernous airport terminal with comforting light.

Co-existing with the use of stained glass in an architectural setting were those who used glass as a means of artistic expression and pushed the traditional boundaries of the medium to produce hybrid sculptural objects and decorative items. Dale Chihuly and others in the modern studio glass movement worked with glass free of the weight of historical constraints and architectural boundaries. Today, Chihuly is famous for the blown glass sculptures produced by him and his "team" at his Pilchuck School in Washington. This artist's interests in glass date to his undergraduate studies in architecture and interior design. Following experimentation with the medium, he produced for his mother's dining room window a curtain of woven fibers encasing rectangles of glass. The artist subsequently studied glass as a graduate student at the Rhode Island School of Design (RISD), which is an important center for glass artists today, and won an award from the Louis Comfort Tiffany Foundation to study glass at the Venini factory in Venice. He returned to head the Glass Department at RISD and, after starting Pilchuck in 1971, began with Jamie Carpenter a series of collaborations such as an environmental installation of neon and a number of architectural glass projects, including the Corning Wall for the Corning Museum in 1974.

WHERE IS STAINED GLASS NOW?

In the mid-1960s, the Arts and Crafts movement seemed to have been rediscovered. The reasons for this are not entirely clear, yet it may have something to do with an attraction to the counterculturalism and political radicalism of the earlier movements. The hippie communes of the 1960s may have found a corollary in the idealistic colonies from early in the century. From Woodstock to Grateful Dead concerts, and even today at New Age gatherings, stained glass windows and articles have been a part of the counterculture scene.

Beyond its revival in the 1960s, the legacy of the Arts and Crafts movement has extended to the realm of hobbyists in cities, suburbs, and the country. Stained glass techniques are taught through instructional television, popular magazines, local arts centers, and adult education classes. Stained glass can now be seen at every craft fair, and indeed at every public gathering, garden and flower show, seasonal festival, or street fair, where amateur and professional artisans set up booths and sell their wares. A long way from the majestic windows at Chartres or even the technical innovations of Tiffany Studios, these staples of the tourist market—mushrooms and hummingbirds in the mountains, sailboats and fish at oceanside—have in some ways fulfilled the Arts and Crafts ideal of handcrafted items in every home.

The pluralism permeating the arts in the late twentieth century also defines the work of stained glass in the era. Like Chihuly's woven glass curtain, a variety of applications and approaches to stained glass are used by contemporary artists, artisans, and craftsmen. Whether producing stained glass for public art commissions or architectural settings, or using stained glass alone or in combination with other materials to produce objects for the commercial market, artists who use stained glass are part of a thousand-year-old artistic tradition of light transformed by color.

The Corning Wall

Dale Chihuly and James Carpenter, 1974; blown glass roundels with thread glass decoration, cut, leaded and signed; 77¾ x 49 in. (199.4 x 125.8 cm). Corning Museum of Glass, Corning, New York.

Chihuly is today known worldwide as the director of teams of artisans who produce innovative and highly original blown glass sculptures. This early collaboration—with blown and spun glass roundels that recall the origins of stained glass—reveals Chihuly's love and facility for the medium.

127

CONTENTS

Page numbers in **boldface** type indicate photo captions.

Alberti, Leon Battista, 14, 26–29
 Della pittura, 12, 29
 De re aedificatoria libri X, 12, 29
 Palazzo Rucellai, **26**, 29
 Santa Maria Novella, Facade, **29**
 Sant'Andrea, Nave, **28**, 29
alchemy, 15
Apollo Belvedere (antique statue), 66
art for art's sake, 99
astrology, 15
atmospheric perspective, 14, 34, 50, 51

Baptistery of Florence, 26
 Doors (Ghiberti), 30, **30**
Barbari, Jacopo de, map of Venice, **104–5**
Baroque painting, 113
Bartolommeo, Fra, *Vision of St. Bernard*, **93**
Bautista de Toledo, Juan, The Escorial, 58, **58**
Bible, 16, 62–63, 65
Bologna, Giovanni, 103
 The Rape of the Sabine Women, **10**
Bolognese Academy, 113
Borghese Palace (Rome), room in, **122**
Bosch, Hieronymus, *Garden of Earthly Delights*, **60**, 61
Botticelli, Sandro, 33
 The Birth of Venus, 33, 38, **39**
 Primavera, **6**
Bramante, Donato, 80
 medal depicting St. Peter's, **74**
 design for elevation of St. Peter's, **80**
 Tempietto, 80, **81**
Bronzino, Agnolo, 103, 112–13
 Lucrezia Panciatichi, 113, **113**
Bruegel, Pieter, the Elder, 55
 The Battle Between Carnival and Lent, 55, **56–57**
 The Return of the Hunters, **55**
 The Tower of Babel, **19**
Bruges, 49
Brunelleschi, Filippo, 14, 23–26, 29, 34
 Florence Cathedral, Dome, **22**, 23–26, **23**, 29
 Old Sacristy of San Lorenzo, 26, **27**
 Ospedale degli Innocenti (Foundling Hospital), **44**
Buonsignori, S., *View of Florence*, **20–21**

Castagno, Andrea del, *The Last Supper*, **24–25**
Castelfranco, Zorzi da, 109
Cellini, Benvenuto, 58, 103
 salt cellar, **126**
Chambord, Château de, 58, **58**
Champin, Robert (Master of Flemalle), 50–51
 Merode Altarpiece, 51
 Saint Barbara, 50–51, **50**
Colosseum (Rome), **18**
Copernicus, 16
Correggio (Antonio Allegri), **108**
 Jupiter and Io, **108**
 Vision of St. John the Evangelist, **120–21**
Cosimo, Piero di, *Perseus Liberating Andromeda*, **94**
Council of Constance, 7
Council of Trent, 63, 108
Counter-Reformation, 107–8

Dadaism, 102
Dante, 21
domestic scenes, 65
Donatello (Donato di Niccolo di Betto Bardi), 23, 32–33, 77
 David, 32–33, **32**, 38
 Equestrian Monument of Gattamelata, **45**
 Mary Magdalene, 32
Dürer, Albrecht, 16, 65–66
 Adam and Eve (The Fall of Man), 66, **66**
 The Great Piece of Turf, **67**
 Melancholia, **65**
 Revelation of St. John woodblock print series, 66
 Self Portrait, **64**

Early Renaissance, 21–39
England, 58
engraving, 66
Eyck, Jan van, 51
 Canon van der Paele, portrait of, 55
 The Crucifixion, **8–9**
 Ghent Altarpiece, 51, **52–53**
 Giovanni Arnolfini and his Bride, **54**, 55
 Organ from The Ghent Altarpiece, **51**

Florence, 21, 39, 66, 73, 108
France, 50, 58
Francis of Assisi, Saint, 12
funerary art, 74–77

Galileo, 16, 21
Germany, 50
Ghent, 49

Ghiberti, Lorenzo, 77
 Baptistery doors, 30
 The Gates of Paradise (Baptistery Doors), 30, **30**
 Self-Portrait, **31**
Giorgione, 109
 Sleeping Venus, 111, **111**
 The Tempest, 109, **109**
Goes, Hugo van der, *The Portinari Altarpiece*, **68–69**
Golden House (Rome) (Nero's), 33
Gothic style, 49, 50
Goujon, Jean, *The Nymph of the Seine*, **71**
Great Schism, 7, 62
Grünewald, Matthias, 61–62
 The Crucifixion (Isenheim Altarpiece), **63**
 Isenheim Altarpiece, 61–62, **61, 63**
 The Resurrection (Isenheim Altarpiece), 61–62, **61**
Gutenberg, Johann, 16

Habsburg family, 60
Herrera, Juan de, The Escorial, 58, **58**
High Renaissance, 73–87, 99
Holbein, Hans, the Younger, *The French Ambassadors*, 58–60, **59**
humanism, 4, 12–15, 50

Ignazio, Danti, street plan of Rome, **75**
individualism, 12–14
Italy, 58

Kepler, Johannes, 61

landscape, 65
Laocoön Group (antique statue), **11**, 12
Leonardo da Vinci, 14, 21, 58, 73, 78, 82–85
 The Battle of Anghiari, 85, **85**
 Drawing of an Infant, **84**
 Flower Studies, **82**
 Mona Lisa, **83**
 Virgin of the Rocks, **95**
Limbourg Brothers, *Les Très Riches Heures du Duc de Berry* (Book of Hours for the Duke of Berry), **48**, 49
linear perspective, 14, 23, 34, 50, 99
Lippi, Fra Filippo, 38
 Madonna and Child, **43**
Louvre (Paris), 58

Machiavelli, 21
Magellan, Ferdinand, 16
Mannerism, 29, 99–113
Mantegna, Andrea, 86
 Palazzo Ducale (Mantua), Camera degli Sposi, ceiling fresco, **40–41**
 Parnassus, 38, **38**
 St. Sebastian, 32
manuscripts, ancient, 7–12
Masaccio, 86
 The Tribute Money, 34, **34–35**
Master of Flemalle. See Champin, Robert
mathematics, 15–16
Medici, Cosimo de', 7, 11, 21
Medici, Giovanni de', 21, 26, 77
Medici, Giuliano de', 77
Medici, Lorenzo de', 21, 23, 77
Medici family, 38, 39, 113
Michelangelo, 14, 21, 29, 73, 74–78, 80, 99–100
 Church of San Lorenzo, Facade, 99–100
 The Creation of Adam (Sistine Chapel), 78, **78–79**
 Dawn, **99**
 The Last Judgment (Sistine Chapel), 103–7, **106**, 108
 Laurentian Library, Entrance Hall, 100, **100–101**
 Medici Chapel in S. Lorenzo, 100, **123**
 Moses, 78
 The Pietà, 77, **77**
 Sistine Chapel, ceiling frescoes, **72–73**, 77–78, **78–79**, 103–7, **106**, 108
 St. Peter's, **14**, 15
 tomb of Duke of Urbino, 77
 tomb of Julius II, 74–77, 78
 tombs of Giuliano and Lorenzo de' Medici, 26, 77, 100
money economy, 14
mythology, 38

naturalism, 113
Netherlands, 49–50
Niccoli, Niccolo, 7–11
Nonsuch Palace (Surrey, England), 58
Northern Renaissance, 49–66
nudity, 32–33, 38, 108, 110–11

oil painting, 50, 85

Palazzo Vecchio (Florence), Courtyard (Arnolfo di Cambio; Vasari), **125**
Palladio, Andrea, Villa Rotunda (Villa Capra), **124**
Pantheon (Rome), **17**, 23, 26
Parmigianino, Francesco:
 Madonna of the Long Neck, **98**, 99
 Self-Portrait in a Convex Mirror, 102, **103**
patronage, 21, 23
Paul III Directing the Continuance of St. Peter's (fresco) (Great Hall,

Palazzo della Cancelleria), **127**
perspective, 14, 15–16, 23, 34–37, 50, 51, 99
Perugino, Pietro, 86
 Charge to Peter (Christ Giving the Keys to St. Peter), 86, **87**
Petrarch, 12–14
Piero della Francesca, 34–37, 86
 The Battle of Heraclitus and Chosroes, **36–37**, 37
 Portrait of Battista Sforza, **42**
 The Proving of the True Cross, 36–37
 San Francesco in Arezzo, apse fresco cycle, 36–37
Platonic Academy of Philosophy (Florence), 23
Pliny the Elder, *Natural History*, 11–12, 16, 29
Pollaiuolo, Antonio di, *Hercules and the Hydra*, **47**
Pontormo, Jacopo:
 Cosimo de' Medici, the Elder, **114**
 Joseph in Egypt, 102, 112
Pop art, 102
portraiture, 51–55
Post-Renaissance art, 113
printing press, 4, 16, 65

Raphael, 33, 86–87
 Disputa, 87
 Farnese Palace, ceiling frescoes in loggia, **5**
 Galatea, **91**
 The Marriage of the Virgin, 86, **86**
 The School of Athens, 87, **88–89**
 Sistine Madonna, **92**
 Stanza della Segnatura (Vatican), frescoes, 86–87
realism, 49
Reformation, 62–65
Renaissance, origin of term, 4
Rome, 73
Rossellino, Bernardo, *Tomb of Leonardo Bruni*, **46**
Rovezzano, Benedetto da, 58

Sack of Rome, 21–23
Sangallo, Antonio, Farnese Palace, **90**
San Lorenzo basilica (Florence), 26
Sansovino, Jacopo, La Zecca (The Mint) and Library of S. Marco, **118, 119**
Santa Maria della Consolazione (Todi), **97**
Savonarola, Girolamo, 39
science, 14–15
scriptoria, 7
Signorelli, Luca, *The Damned Cast into Hell*, **96**
Spain, 58
still life, 65
St. Peter's Cathedral (Rome), **14**, 15, 74, **74**, 80
 reconstruction of, under Bramante, 80

technology, 15–16
The Three Graces (antique statue), **13**
Tintoretto, 111–12
 The Last Supper, 112, **112**
Titian, 109, 110–11, 112
 The Bacchanal of the Andrians, **115**
 Sacred and Profane Love, **116–17**
 Venus of Urbino, 110–11, **110–11**
Tornabuoni family, 39
Torrigiano, Pietro, 58
Toscanelli, Paolo, Plan of the World, 49
Tournai, 49
trade, 14
Tuscan League, 21

Uccello, Paolo, 33, 34
 The Battle of San Romano, 34, **35**

Varagine, Jacobus de, *Golden Legend*, 36
Vasari, Giorgio, 29, 107, 113
 Lives of the Most Excellent Painters, Sculptors and Architects (book), 103
 Perseus and Andromeda, 107, **107**
 Uffizi (Florence), **102**, 107
Vatican Library, 11
Venice, 66, 73, 109
Venus de' Medici (antique statue), 66
Veronese (Paolo Caliari), 109
Verrocchio, Andrea del, *David*, 33
Vespucci, Amerigo, 21
Vitruvius, 66
 De architectura, 11, 23, 26–29

Weyden, Roger van der, *The Sacrament of the Eucharist*, **70**
woodcuts, 66